HODDESDON & BROXBOURNE

THROUGH TIME

David Dent, Sue Garside
& Stephen Jeffery-Poulter

AMBERLEY PUBLISHING

Acknowledgements

The authors would like to thank Neil Robbins, Heritage and Education Officer at Lowewood Museum for supporting this project from the very beginning, and museum staff Pauline Miller and Valerie Wood for all their hard work researching and locating the original photographs and other assistance in checking facts and dates. We are also grateful to Dr Peter Garside for supplying several photos from his private collection, and to Lynn Whitnall for providing the two photographs of Paradise Wildlife Park.

First published 2010

Amberley Publishing Plc
Cirencester Road, Chalford,
Stroud, Gloucestershire, GL6 8PE

www.amberley-books.com

Copyright © David Dent, Sue Garside
& Stephen Jeffery-Poulter, 2010

The right of David Dent, Sue Garside
& Stephen Jeffery-Poulter to be identified as the
Authors of this work has been asserted in
accordance with the Copyrights, Designs and
Patents Act 1988.

ISBN 978 1 4456 0083 3

British Library Cataloguing in Publication Data.
A catalogue record for this book is available from
the British Library.

Typeset in 9.5pt on 12pt Celeste.
Typesetting by Amberley Publishing.
Printed in the UK.

Hoddesdon

The first written record of Hoddesdon is in the Domesday Book, where changes of land ownership from Anglo-Saxon to Norman after the Conquest were detailed. There had been people living in the area long before that – pre-Roman peoples who left little trace; a few small Roman sites and the Roman road, Ermine Street, which we know by a form of its Anglo-Saxon name; the Anglo-Saxons themselves and the Danes, whose territory, Danelaw, was bounded in part by the River Lea. Hoddesdon's name is probably derived from a Saxon or Danish personal name.

By the mid thirteenth century, Ermine Street had deteriorated and the road north from London ran closer to the Lea. The owner of the manor of Hoddesdon recognised the potential of its position and secured a market charter in 1253. Hoddesdon's Y-shaped centre came about because the way north via St. Margaret's and Amwell to Ware was later superseded by the route via Hailey.

Hoddesdon's Thursday market continued until the nineteenth century. A new market, initially primarily for livestock, was established in the 1880s which has evolved into our present general market.

Hoddesdon was not a parish in its own right until the nineteenth century, but it did have a small private chapel at the town centre from 1336 which was also visited by pilgrims to Walsingham. Used for occasional services until the mid seventeenth century, it eventually became a clock tower until its demolition in the nineteenth century to make way for the present Clock Tower.

The population of Hoddesdon grew to such an extent in the nineteenth century that a new parish was created from parts of Broxbourne and Amwell parishes. A private chapel in Amwell Street formed the core of the parish church in the mid nineteenth century. It was extended later in that century and from 1976 has been dedicated to St. Catherine and St. Paul.

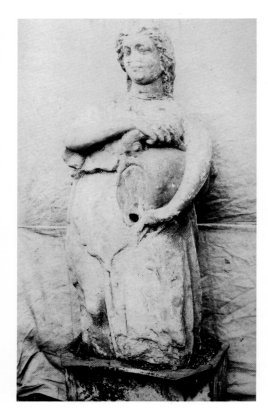

Samaritan Woman
The Samaritan Woman statue in a dilapidated state. From the mid seventeenth century until 1826 she stood at the top of Conduit Lane delivering water from her urn for the people of Hoddesdon. The statue was renovated in 1937 and since 1987 has stood in the garden beside Lowewood Museum.
Lowewood Museum Borough of Broxbourne: Photograph 2002.0626

The town's position on a major road brought trade and employment. Inns catered for travellers, both the wealthy and the poor. Some of the large inns dating from the sixteenth and seventeenth centuries remain to this day. The zenith of road traffic occurred from the mid eighteenth until the mid nineteenth century as improvements in the condition of the roads allowed fast coaches and heavier wagons to throng the highways. The coming of the railways spelled the end for this boom, but road traffic revived towards the end of the nineteenth century with the advent of first the bicycle and then the car. A small brewery, started about 1700, prospered in the nineteenth century to become a major employer in the town until its closure in 1928.

Through the twentieth century Hoddesdon grew rapidly. The town centre changed radically in the 1960s and 1970s, with large scale clearances for the Tower Centre and Fawkon Walk developments and major road re-organisation. The illustrations in this book show how Hoddesdon has changed, but also serve to celebrate the fine buildings that do still exist.

From Nurseries to Homes

From 1971 until 2005 the Carnival procession gathered on the 100 Acre estate and wound its way through Hoddesdon and Broxbourne to finish at Deaconsfield. The Hoddesdon Carnival became the Hoddesdon & Broxbourne Carnival from 1979. The 100 acre estate was built in the late 1960s on these nurseries, bordered by St Margarets Road, Ware Road and Stanstead Road.

Lowewood Museum Borough of Broxbourne: Photograph 1982.085.077

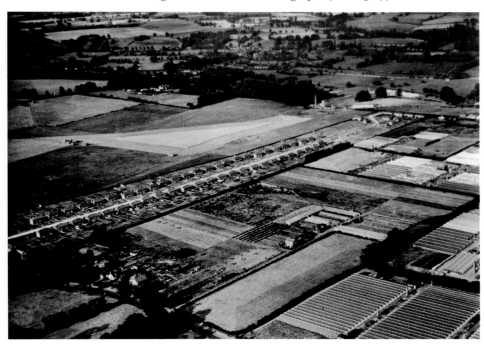

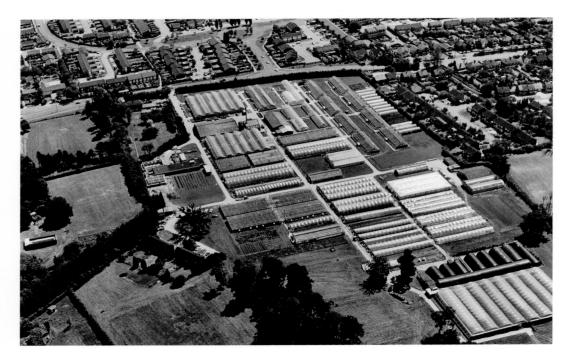

The Last of the Greenhouses

The 100 Acre estate can be seen at the top of the 1970s photograph, with the Roselands estate west of Ware Road, on the right of the photograph. The Lea Valley Experimental Station (MAFF) nurseries dominate the foreground. This site was cleared in the early 2000s for the Boundary Park estate.

Lowewood Museum Borough of Broxbourne: Photograph 2001.0931

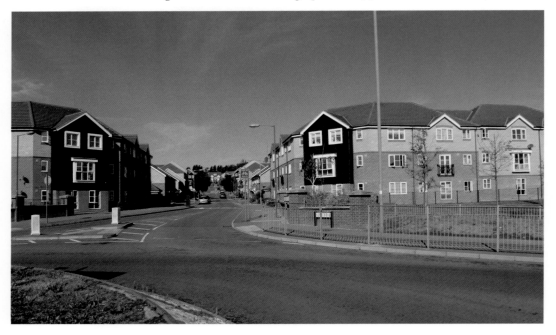

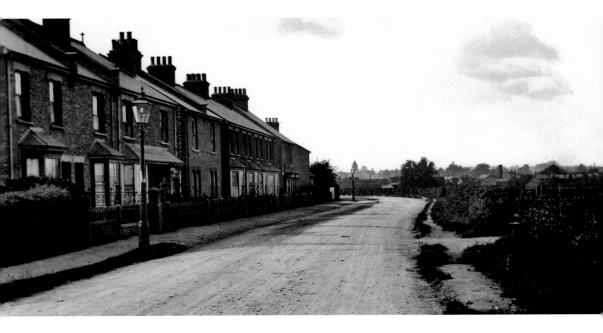

Stanstead Road

Approaching Hoddesdon town centre from the north along Stanstead Road the houses on the left in the view of *c.* 1910 can still be seen, but the open area to the right has disappeared with development along the road and the building of the Forres estate in the 1930s.

Lowewood Museum Borough of Broxbourne: Photograph 1999.1234

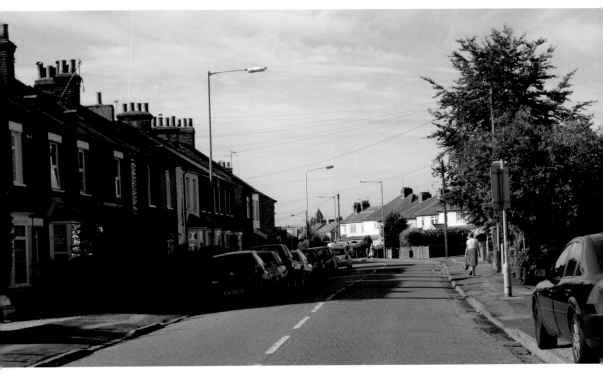

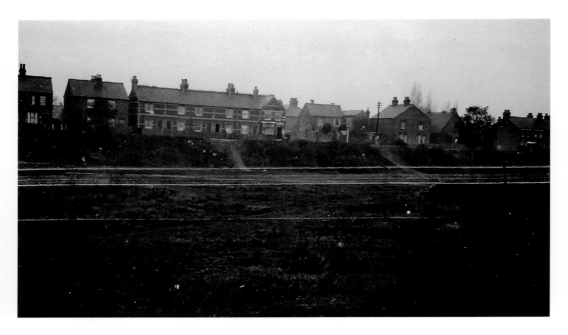

Rye Park Recreation Ground, Old Highway
The area was a gravel pit before being made into the park. The houses along the Old Highway in the background remain with the distinctive patterning on the brickwork of the end houses still visible. The park, viewed here from the Old Highway has play areas and sports facilities.

Inset: Houses in the Old Highway.

Lowewood Museum Borough of Broxbourne: Photograph 1982.085.059

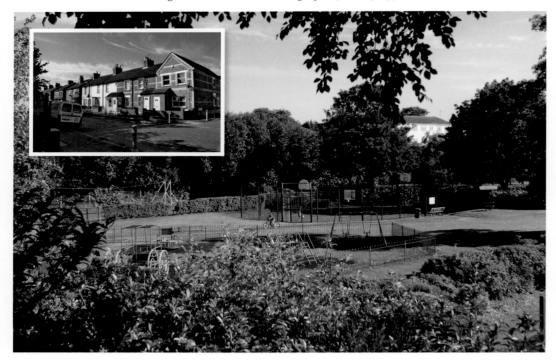

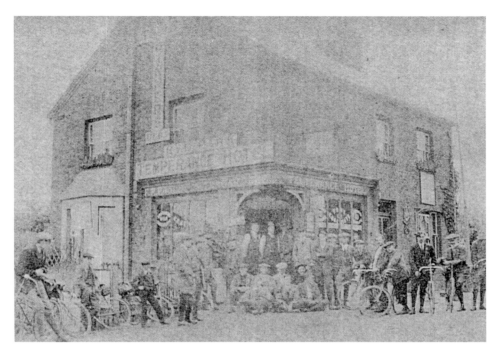

Temperance Hotel, Rye Road
Teetotallers wishing to visit Rye House could stop here and had only a short walk (or cycle ride) to reach the pleasure gardens and amusements. The building remains much the same today.
Lowewood Museum Borough of Broxbourne: Photograph 1999.1458

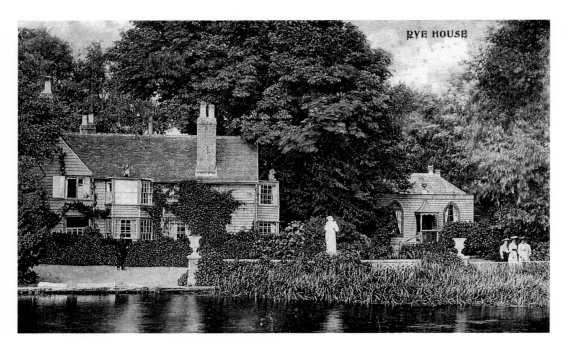

Rye House Inn

The Rye House hotel, catering for the drinking public, was an integral part of Henry Teale's Rye House estate based on Rye House Gatehouse. The pub in its river location is still very popular today.

Lowewood Museum Borough of Broxbourne: Photograph 1999.1353

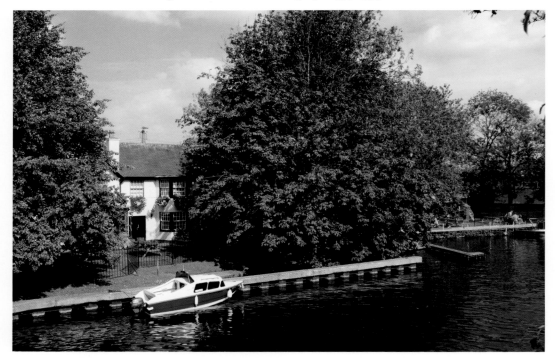

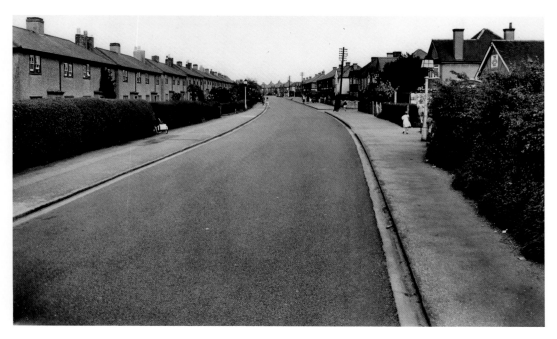

Rye Road

In 1955 Rye Road was a very quiet road. Although the street itself has changed very little, the volume of traffic using it has increased dramatically, with accompanying traffic calming measures.

Lowewood Museum Borough of Broxbourne: Photograph 1985.586

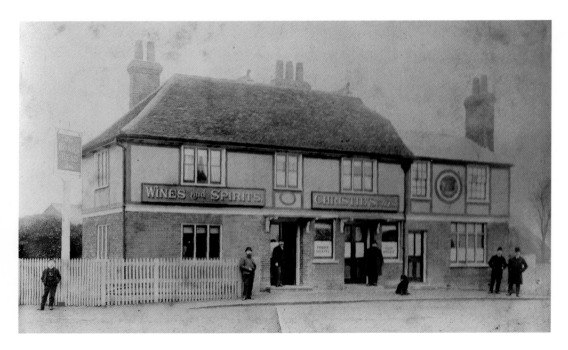

Boars Head

The Boars Head stands on the corner of Stanstead Road and Duke Street. When these patrons were paying a visit in 1872, the pub was close to the edge of Hoddesdon, with farms close by, nurseries to the north and the common land that was to become Rye Park not yet sold for housing. The pub exterior has changed little over the years.

Lowewood Museum Borough of Broxbourne: Photograph 1982.83.59

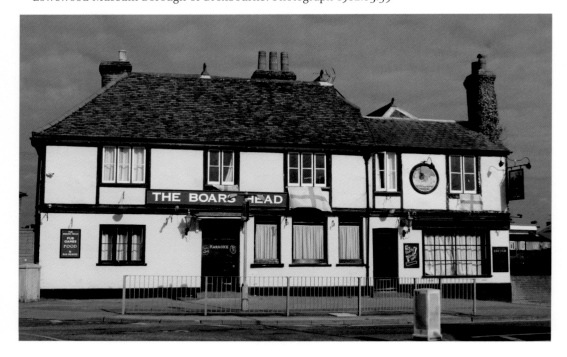

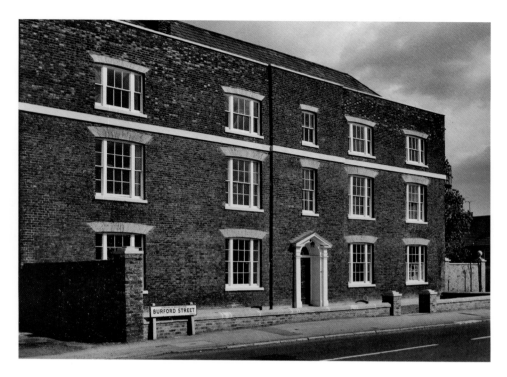

Burford House

The late eighteenth/early nineteenth century building was a school, Burford House Academy, in the mid nineteenth century. In recent years the extension to the south has been built. The earlier photograph shows Burford House after a renovation in 1982.

Lowewood Museum Borough of Broxbourne: Photograph 1992.190

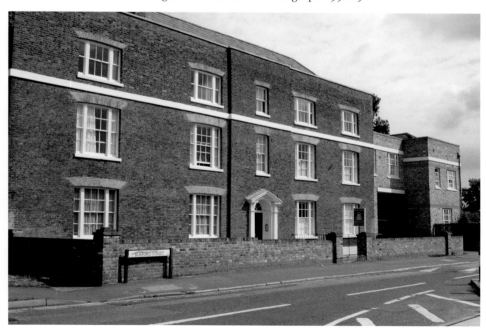

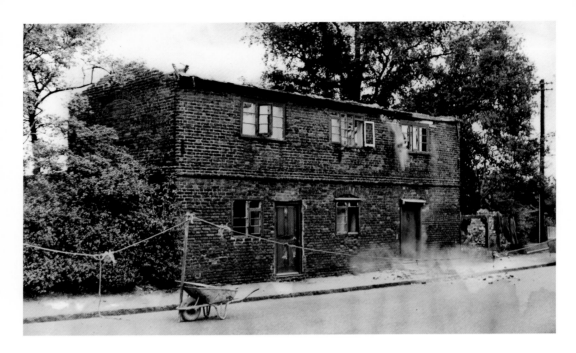

Essex Road

The building under demolition was constructed as a Meeting House for the Society of Friends in 1697 when it stood in isolation in an otherwise empty lane. When the Society moved to Lord Street this building was converted to two cottages, which were cleared in 1956 to make way for new housing.

Lowewood Museum Borough of Broxbourne: Photograph 1985.541

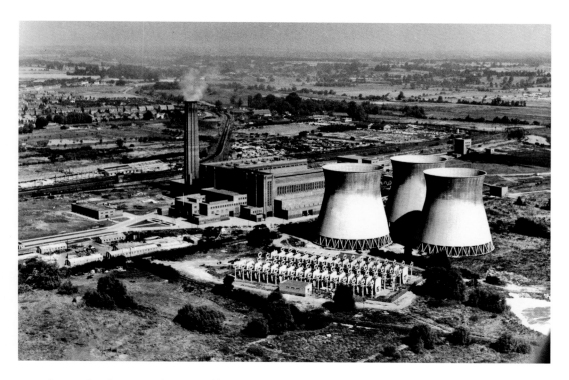

Power Station, Ratty's Lane, off Essex Road
The power station which came into commission in the early 1950s was designed by Sir Giles Gilbert Scott. It was demolished in the late 1980s to make way for the new combined cycle gas powered station which has been in operation since 1994.
 Lowewood Museum Borough of Broxbourne: Photograph 2005.0053

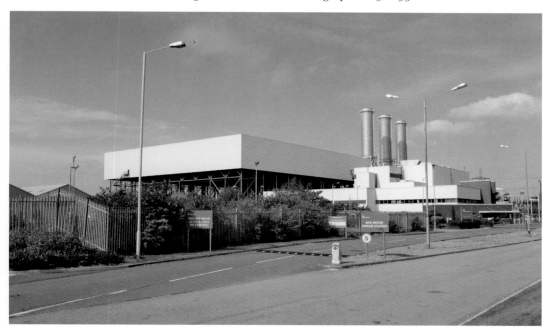

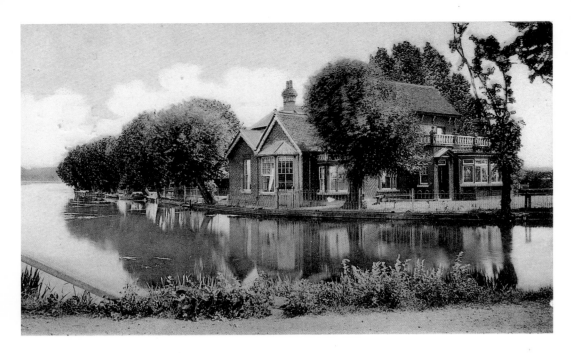

The Fish and Eels, Dobbs Weir

The Fish and Eels pub, in views spanning about one hundred years, is situated across the River Lee on the upper side of Dobbs Weir. The pool below the weir is a popular spot for picnickers, anglers and canoeists.

Lowewood Museum Borough of Broxbourne: Photograph 1993.165

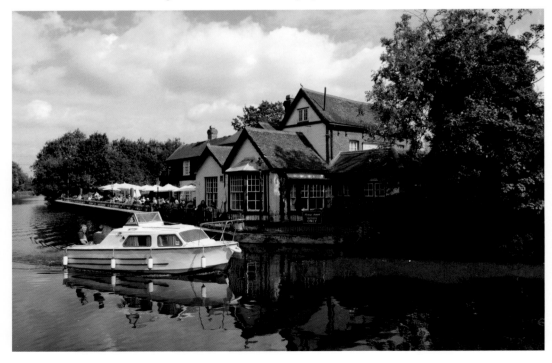

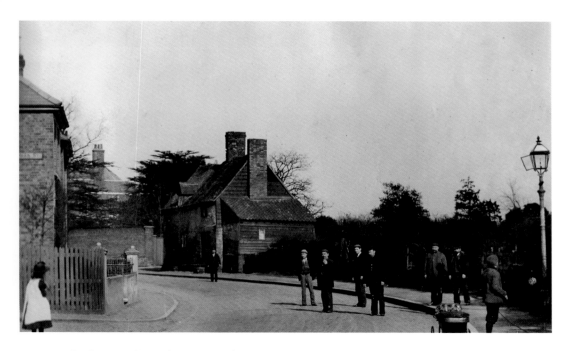

Burford Street from the corner of Roman Street

Roman Street was laid out in 1874 and named for the Roman finds unearthed there. The cottages in the middle distance, situated at the south corner of Essex Road were demolished in 1886. The Baptist Church just set back from the corner was built in 1914.

Lowewood Museum Borough of Broxbourne: Photograph 1982.82.70

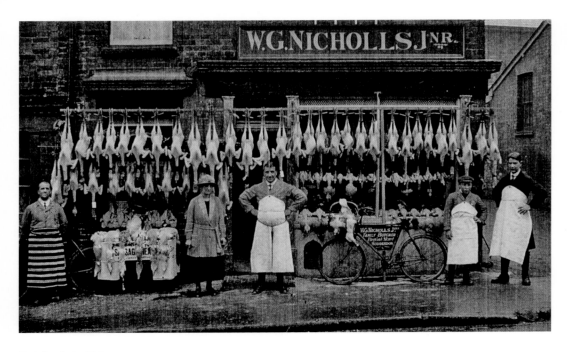

Butcher's to Takeaway

Nicholl's Family Butcher's stood on the corner of Burford Street and Bell Lane. Note all the poultry hanging outside – no worries about food hygiene in the 1920s! Today, in line with our modern eating trends, the shop is a takeaway.

Lowewood Museum Borough of Broxbourne: Photograph 1999.1342

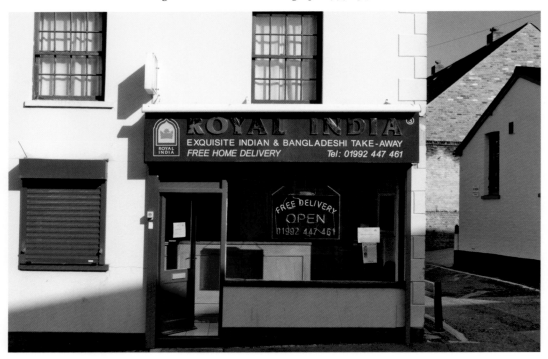

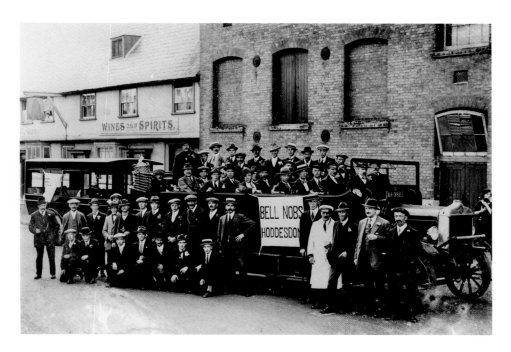

The Bell Inn

A pub outing about to set off, pictured outside the Bell Inn and Christie's Brewery in the 1920s. Under the Christie family's ownership the brewery had expanded greatly in the nineteenth century. The part of the brewery next to the Bell was converted to the Pavilion Cinema after the brewery closed in 1928, and now houses an insurance office and shop. The Bell was documented as an inn in 1634, but may well have been licensed earlier.

Lowewood Museum Borough of Broxbourne: Photograph 2005.0197

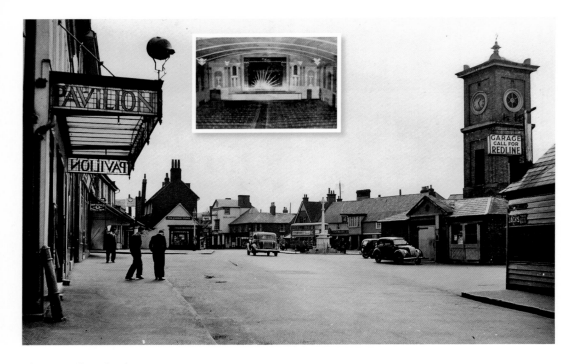

The Top of Burford Street

Where Burford Street reaches the High Street, the Pavilion Cinema entertained cinema-goers from 1930 to 1972. The Clock Tower, then known as the Clock House because of its surrounding buildings, remains a familiar presence in the town centre.

Inset: The interior of the Pavilion Cinema at its opening in 1930.

Lowewood Museum Borough of Broxbourne: Photograph 1997.0182

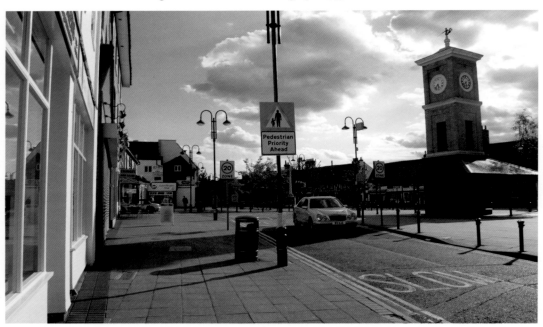

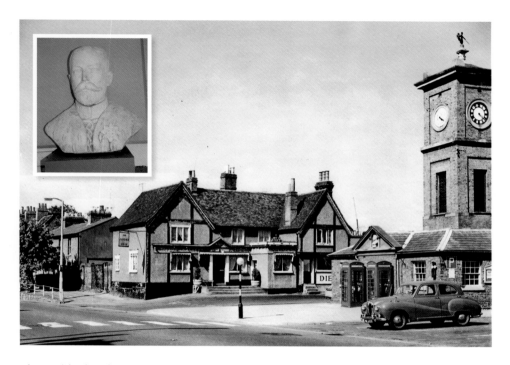

The Maidenhead, and the Clock Tower

The Maidenhead, first mentioned as an inn in 1576, was demolished along with the rest of the buildings to make way for the Tower Centre. The surrounding rooms of the Clock House, with busts of George V, George VI and Edward VII, were also removed, leaving just the Clock Tower.

Inset: Bust of George V.

Lowewood Museum Borough of Broxbourne: Photograph 1992.350

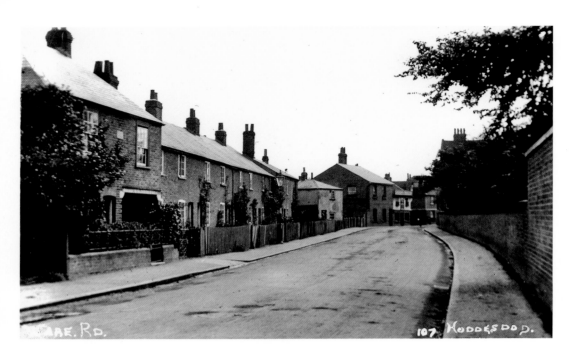

Ware Road

Approaching Hoddesdon from the north along the Ware Road, the Fourways junction can be seen in the distance. The building on the far left and the row of cottages, although re-furbished, are recognisable, but the view to the right and the Fourways junction are very different.

Lowewood Museum Borough of Broxbourne: Photograph 1999.1232

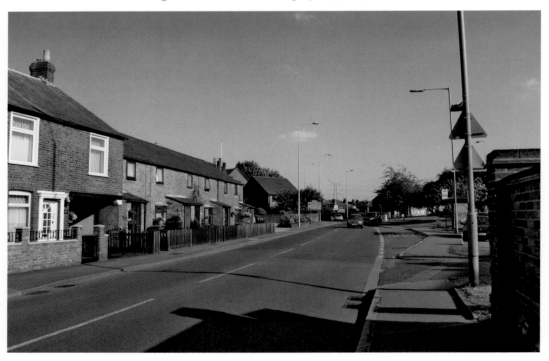

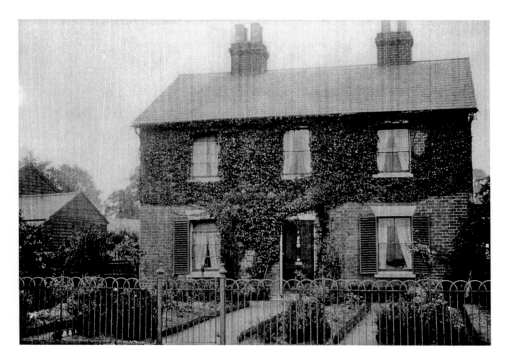

New Farm, Ware Road

In the Fourways area the 1898 Ordnance Survey map shows Manor Farm off Duke Street and Cherry Tree Farm off Hertford Road as well as New Farm. The house, photographed above in *c.* 1950 remains, but all the farmland has been developed for housing.

Lowewood Museum Borough of Broxbourne: Photograph 1999.1316

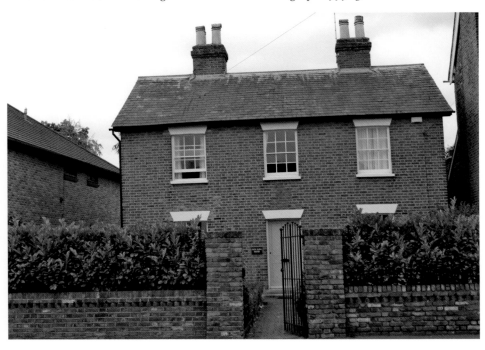

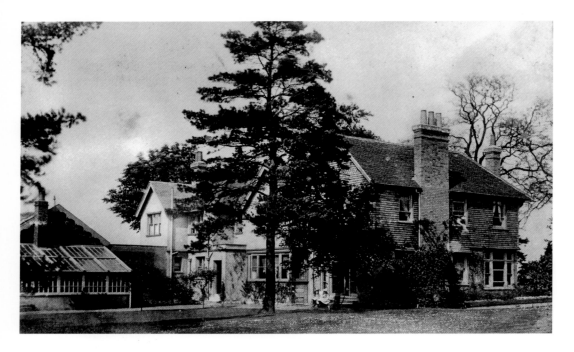

Westfield

Westfield was one of the Hoddesdon's large fields in the days of the open field system when tenants of manors held various strips of land within the fields. An Enclosure Act of 1855 ended the open field system for Hoddesdon. Westfield House, seen here in 1897, was situated in a lane, now called Westfield Road, off Hertford Road. Westfield School, built in 1964, stands on the approximate site of the house.

Lowewood Museum Borough of Broxbourne: Photograph 2002.0020

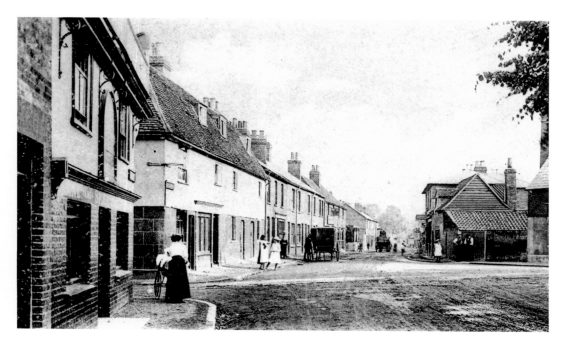

Fourways

The view from Fourways towards the town centre now is very different from that in 1900. The Duke William of Cumberland public house on the north-east corner and all the western side of Amwell Street as far as Woolens Brook were demolished in 1974.

Lowewood Museum Borough of Broxbourne: Photograph 1992.270

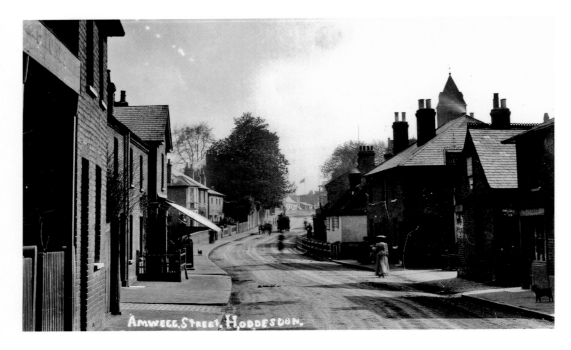

Amwell Street, Woolens Brook

This view of Amwell Street of *c.* 1910 looking south up towards the town centre has changed markedly. The buildings on the extreme left and the church tower on the right are all that give a clue to the location. Now the Tower Centre looms in the background, Woolens Brook flows in a culvert beneath the Dinant Relief Road/A10 slip road roundabout and dual carriageway road takes the place of the buildings on the right.

Lowewood Museum Borough of Broxbourne: Photograph 1999.1229

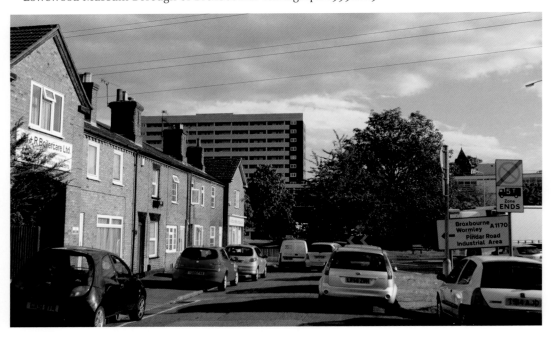

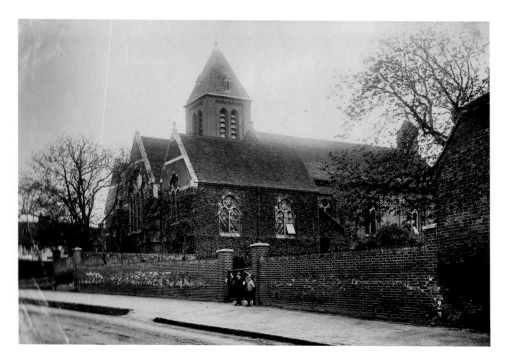

From Private Chapel to Parish Church

Hoddesdon only became a parish in the nineteenth century, having previously being divided between Great Amwell and Broxbourne parishes. A private chapel, the rear of the present building, was the parish church until 1864, when transepts and chancel were added. The final phase was the addition of the tower in 1887.

Lowewood Museum Borough of Broxbourne: Photograph 1982.82.25

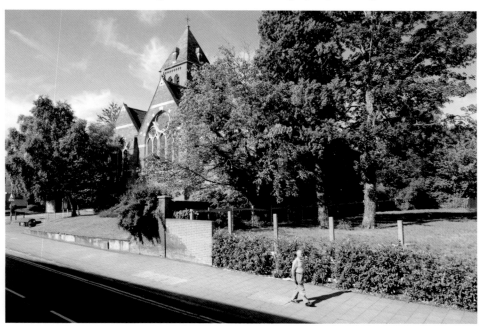

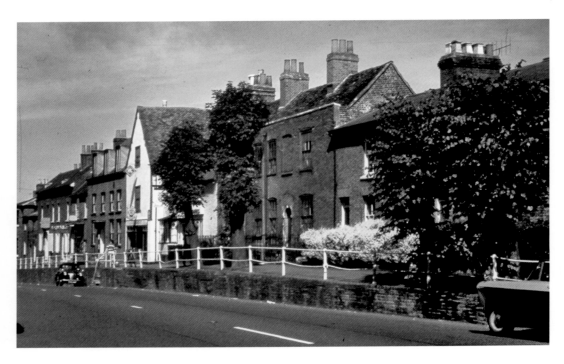

The High Pavement, Amwell Street
The attractive mix of buildings in the triangle bordered by Amwell Street, Burford Street and Woolens Brook was demolished in the early 1960s to be replaced by the Tower Centre, which was completed in 1967.

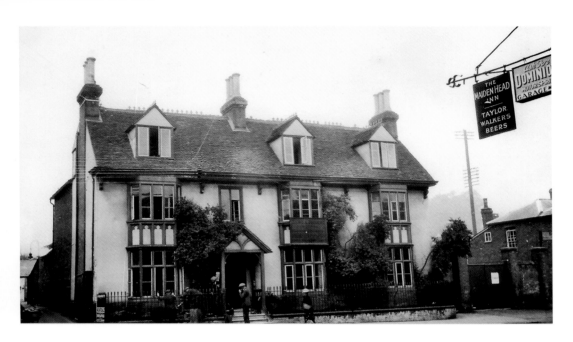

Myddleton House

Built around 1620, this private residence became a pub, The Queen's Head, in the eighteenth century. Back in private hands in the middle of the nineteenth century, it was the home of Charles Christie of the brewery in the later nineteenth century. Later it was converted to shops and has been extended.

Lowewood Museum Borough of Broxbourne: Photograph 1985.085.37

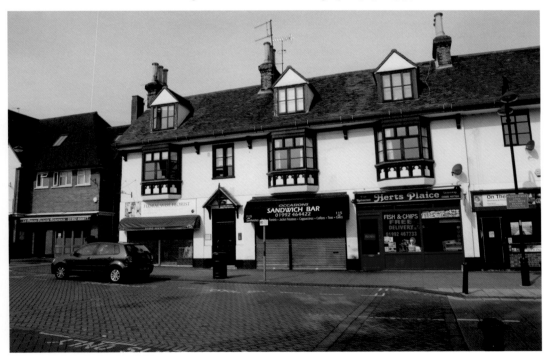

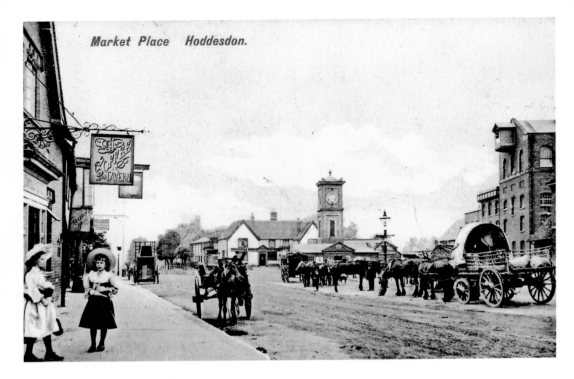

Market Place Hoddesdon.

Town Centre, looking North

From the corner of Lord Street, with the Coffee Tavern on the left, the view of *c.* 1905 shows the height of the main brewery building (right) when it was in operation. The brewery closed in 1928. The 1937 view shows the building in its truncated form. To the right of it, the building with the panel depicting boys with bunches of hops was the site of the Thatched House Inn, the brewery of which evolved into Christie's Brewery.

Lowewood Museum Borough of Broxbourne: Photos 1992.269; 1995.321c

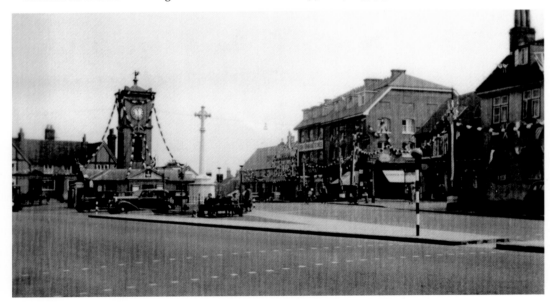

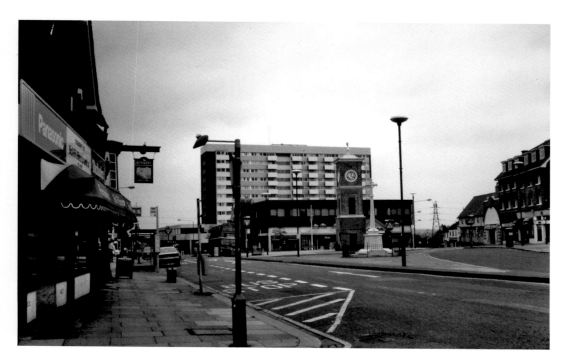

Town Centre, looking North

Taken from the same place as the *c.* 1905 view, this 1989 photograph shows a very different scene, although the buildings on the right remain essentially unchanged from the 1937 view except that the Pavilion Cinema became a bingo hall. The shelter around the Clock Tower in the modern view was constructed in 2003.

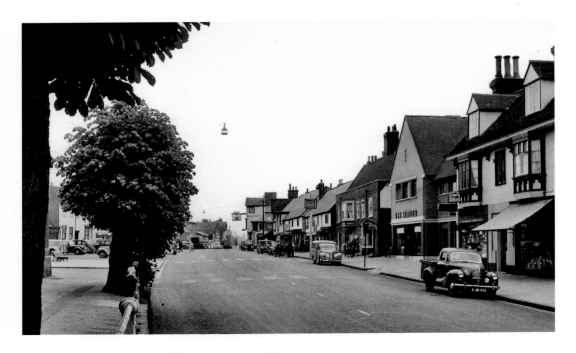

Looking South along the High Street, West Side
A tranquil 1950s view of the High Street, featuring three of its ancient inns, the Bull, the White Swan and the Salisbury Arms, and also Myddleton House. Today's scene is lacking the Bull, demolished in 1964.

Lowewood Museum Borough of Broxbourne: Photograph 1997.0179

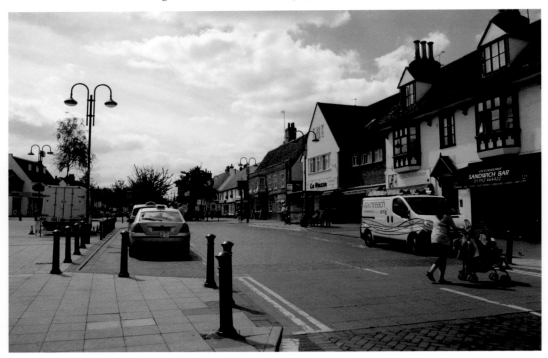

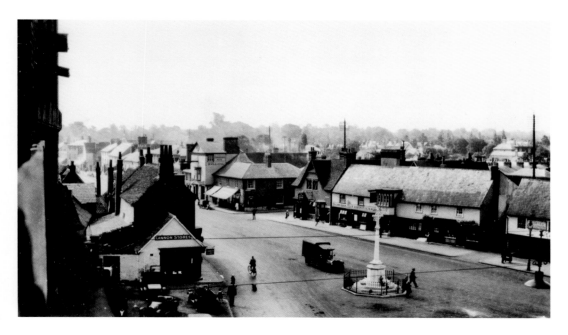

Beer or Coffee?

The White Swan announces its allegiance to Christie's Brewery from which this photograph was taken before the brewery's closure in 1928. The building on the corner of Lord Street to the left of the Swan was the Coffee Tavern, devoted to tempting drinkers away from alcohol. The Swan remains, the Coffee Tavern is now a shop. The War Memorial was unveiled in 1921.

Lowewood Museum Borough of Broxbourne: Photograph 1985.138

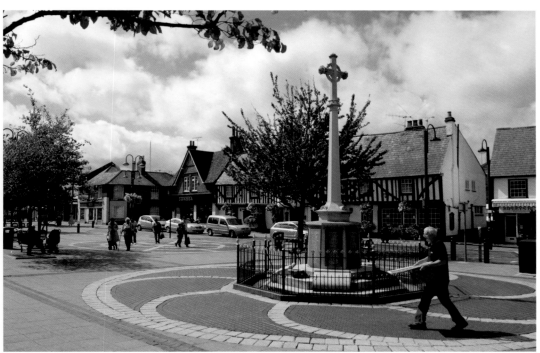

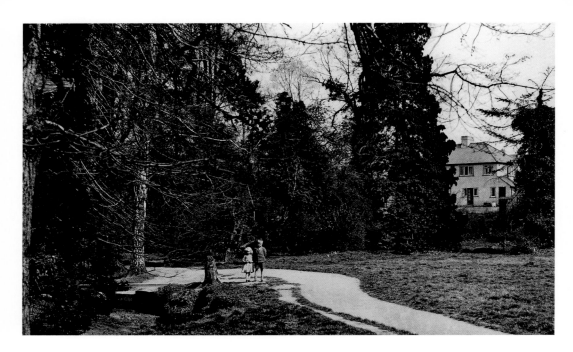

Brookside

Originally part of the garden of Norris Lodge (inset) on Lord Street, this strip of land beside Woolens Brook remained open when the house was demolished in the 1930s. A path from Langton Road still runs through it, crossing the brook at the far end.

Inset: Dr. Bisdee in the garden of Norris Lodge in 1897.

Lowewood Museum Borough of Broxbourne: Photos 1997.0188; 1982.82.84

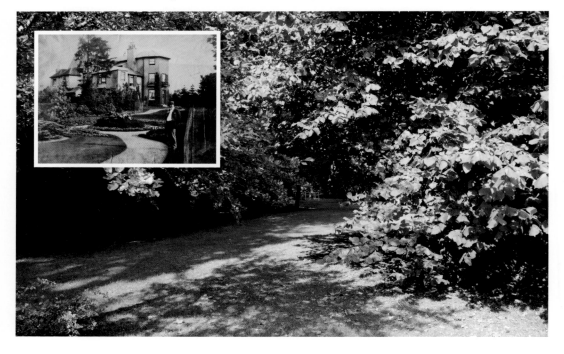

34

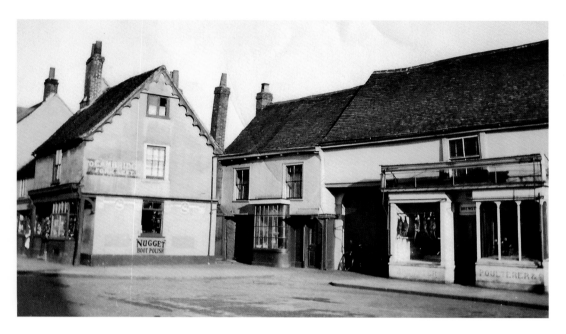

Parish Boundary

The gable-ended building on the left with seventeenth-century timber framing still stands in the High Street, but the buildings to its right were demolished in 1955. The one on the far right was a pub, the White Hart, in the seventeenth century. It straddled the old Great Amwell/Broxbourne parish boundary, which is marked today by a stone set in the pavement.

Lowewood Museum Borough of Broxbourne: Photograph 1985.085.39

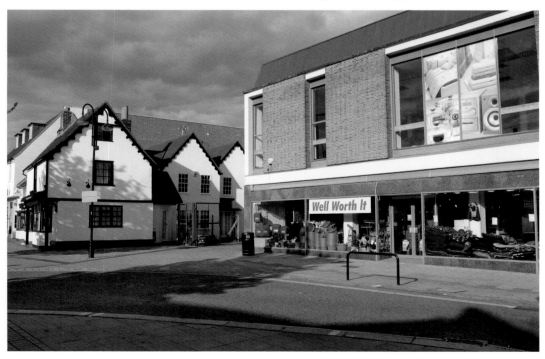

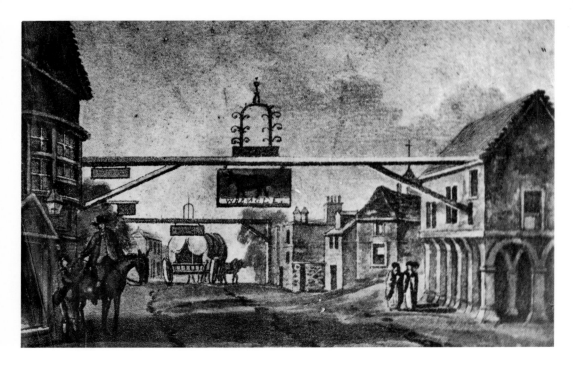

The High Street, 1830 and *c.* 1850
The sixteenth-century Bull Inn on the left had a 'gallows' sign which reached across the road to the seventeenth-century Market House. The tower of the old chapel/clock-house is visible behind Middle Row which had developed from market stalls. The Market House was pulled down in 1833. The old chapel/clock-house was replaced by the new Clock House in 1836. Middle Row was cleared away in the 1850s. In the foreground is the Fox Inn.
 Lowewood Museum Borough of Broxbourne: Photos 1982.82.1; 1996.664

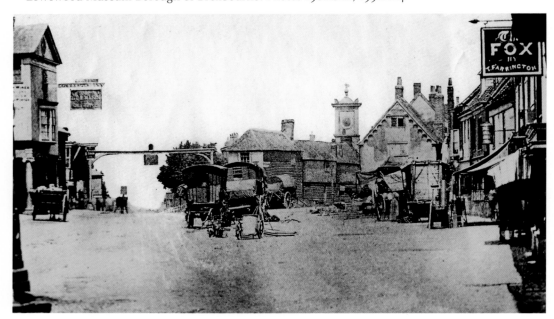

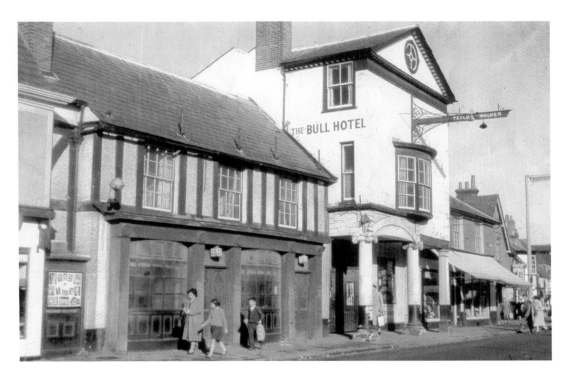

Bull Inn, early 1960s

The Bull Inn, having been a familiar landmark in the middle of Hoddesdon for the best part of four centuries, was closed in 1960. It was demolished in 1964, to be replaced with a shop building, now Peacocks, viewed here in the background on market day.

Lowewood Museum Borough of Broxbourne: Photograph 2002.0055

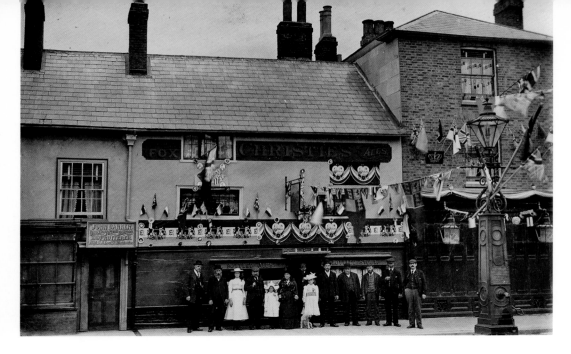

Beer and Water

The group outside the Fox Inn were celebrating the coronation of 1902. The town pump which had an underground tank, replaced a statue, the Samaritan Woman, who delivered her water supply from an urn into an open pool. The pump is long gone and the inn has become shops, but the buildings remain.

Lowewood Museum Borough of Broxbourne: Photograph 1982.83.48

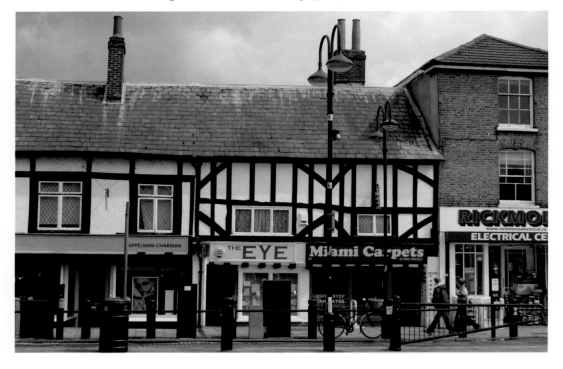

Church to Shops

The congregational church, built in 1847, was demolished in 1967 along with the buildings to its right to make way for the Fawkon Walk shopping development. The name comes from an ancient building on the site called the Fawkon on the Hoop.

Lowewood Museum Borough of Broxbourne: Photograph 1982.370

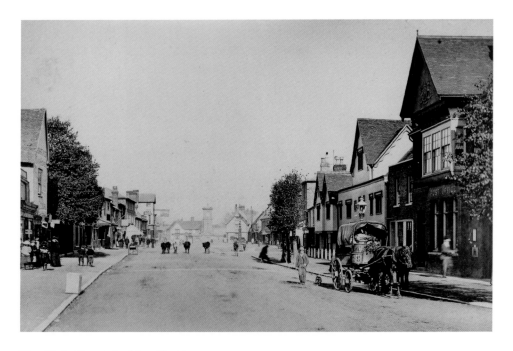

The High Street, looking North

High Street traffic in *c.* 1900 was sparse and somewhat agricultural. The current Post Office, on the extreme right, was built in 1893. Prior to that the Post Office had been in the building on the far left, which afterwards became Ashford's Stores.

 Lowewood Museum Borough of Broxbourne: Photos 1982.84.2; 1999.0031

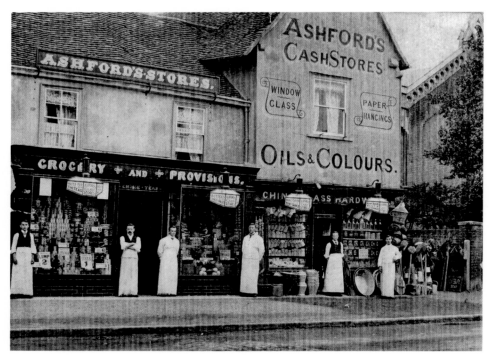

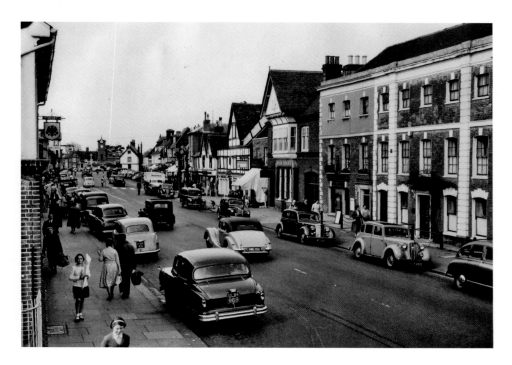

The High Street from the Corner of Brocket Road
Nearly six decades later the High Street buildings looked much the same, but traffic had become mechanised and much more numerous. The red brick building on the right, Montagu House, at that time a doctor's surgery, had been the home of John Loudon McAdam, road building pioneer, in the nineteenth century. The building bears a blue plaque in his memory.

Lowewood Museum Borough of Broxbourne: Photograph 1982.83.54

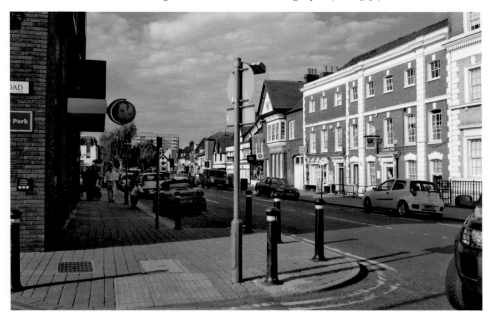

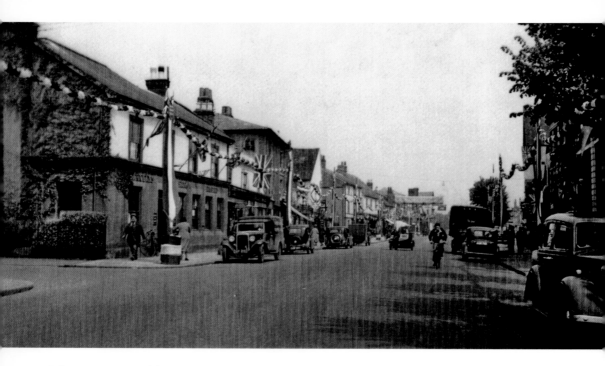

High Street, West Side

The buildings in the centre of the row retain a familiar look when comparing the 1930s view with that of today, but beyond the white gable-ended building is now Fawkon Walk and the bank building on the corner of Brocket Road has been replaced.

Lowewood Museum Borough of Broxbourne: Photograph 1995.321b

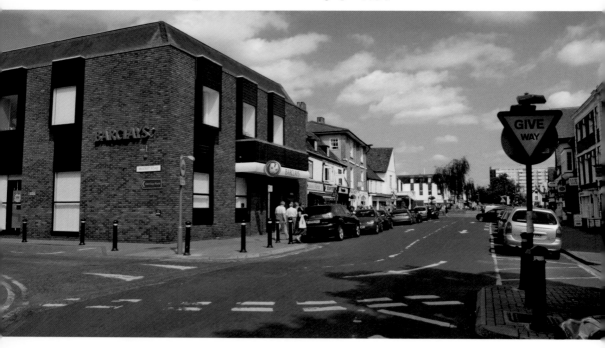

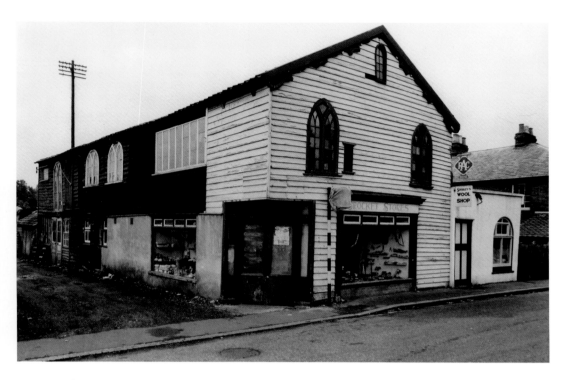

Brocket Stores

Originally a chapel in Nazeing, built in 1816, it was re-built in Brocket Road and became a shop under various ownerships. For many years it was Brocket Stores and is now a restaurant/wine bar.
 Lowewood Museum Borough of Broxbourne: Photograph 1983.522

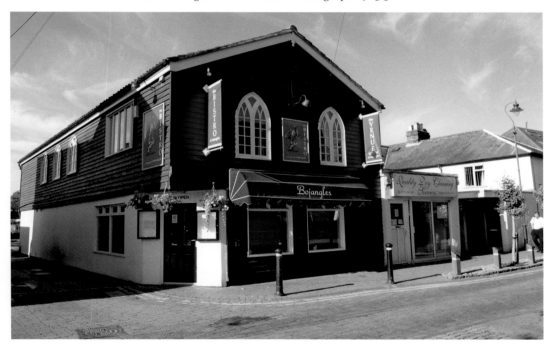

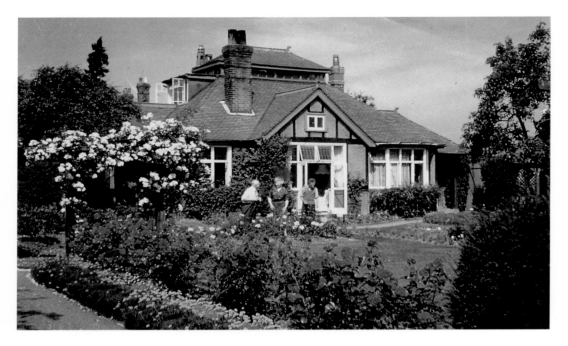

Brocket Lodge

Situated in Brocket Road this attractive house, pictured in 1961, became surrounded by commercial properties over the years. Fawkon Walk ran west beside it leading to a Sainsbury's store. This end of Fawkon Walk was redeveloped in the early twenty-first century and the Aldi supermarket and flats now occupy its site.

Lowewood Museum Borough of Broxbourne: Photograph 2001.0110

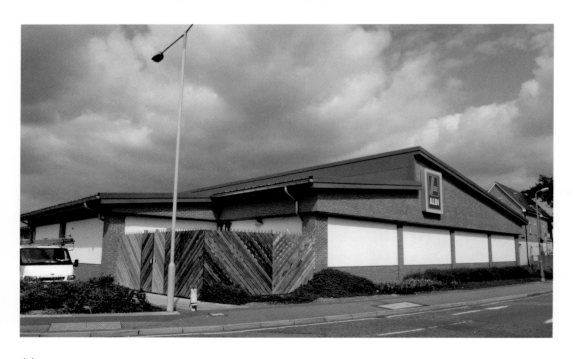

Corner of Brocket Road and Rose Vale

Belmont, seen here in *c.* 1960, was a home for elderly people until a new home was built out along Ware Road at Hailey. Belmont was then demolished and a facility for young people was built on its site.

Lowewood Museum Borough of Broxbourne: Photograph 1982.086.13

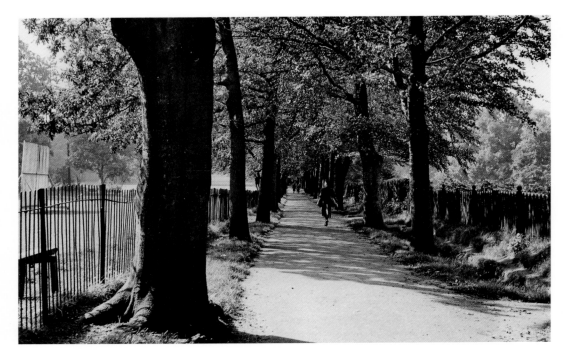

Beech Walk

The beech trees along the walk were planted in 1880 by Robert Barclay of High Leigh. Many of the trees have had to be replaced since the 1960s, but the walk still gives a pleasant access route past the cricket field and tennis club to Barclay Park.

Lowewood Museum Borough of Broxbourne: Photograph 1997.0201

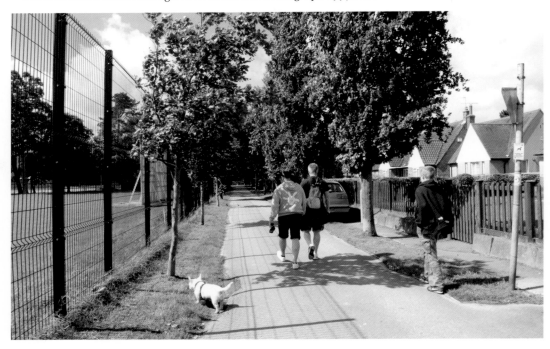

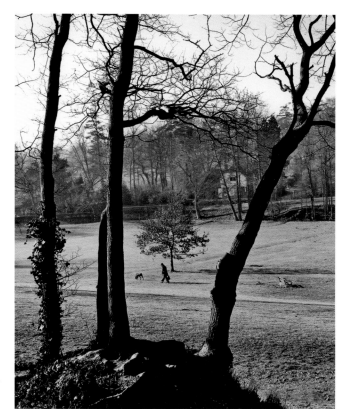

Barclay Park

The entrance lodge, now a private dwelling, of the High Leigh parkland is visible in the 1973 view of the park. The gift of the land by the Barclay family in the 1930s for a town park was a wonderfully generous gesture we are still enjoying today.

Lowewood Museum Borough of Broxbourne: Photograph 1992.166

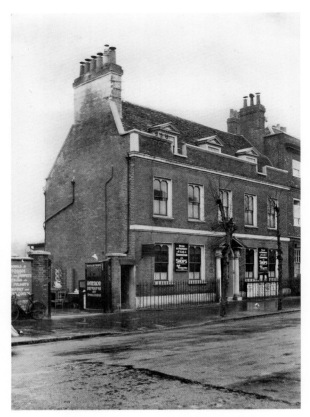

Houses to Businesses

On the east side of the High Street several eighteenth century houses, including no. 58, have undergone conversion to shops and businesses with infill of gaps to make a continuous row. To the right, Rathmore House, no. 56, was known as the Doctors' House, housing doctors' practices from 1812 to 1969.

Lowewood Museum Borough of Broxbourne: Photograph 1982. 085.30

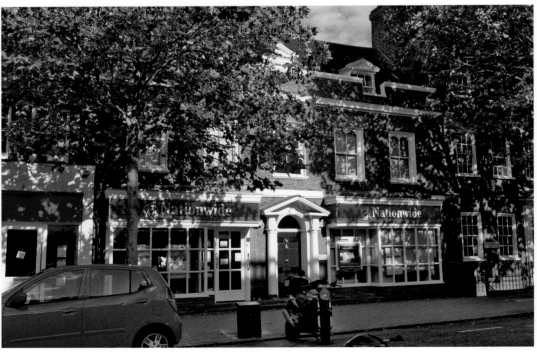

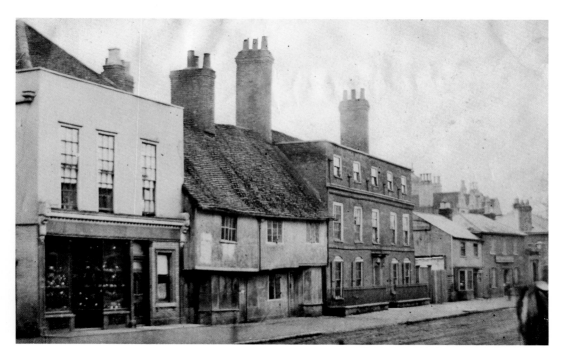

All Change

All the buildings to the south of Rathmore House, just off shot to the left in the nineteenth century view, have gone. Esdale House, the three storey house in the centre was replaced by Esdaile House, which in its turn was demolished for the building of the Roman Catholic Church.

Lowewood Museum Borough of Broxbourne: Photograph 1982.82.52

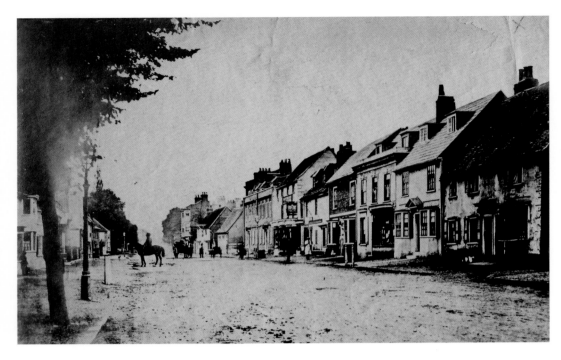

High Street, West Side

The oldest known photograph of the High Street shows the west side from Brocket Road southwards in *c*. 1845. Shops were soon to replace the buildings, including an old inn called the Red Lion, in the middle distance.

Lowewood Museum Borough of Broxbourne: Photograph 1982.82.50

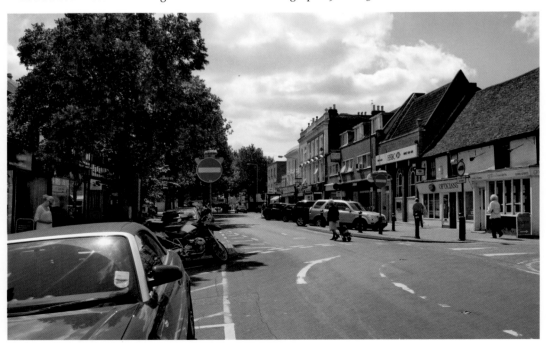

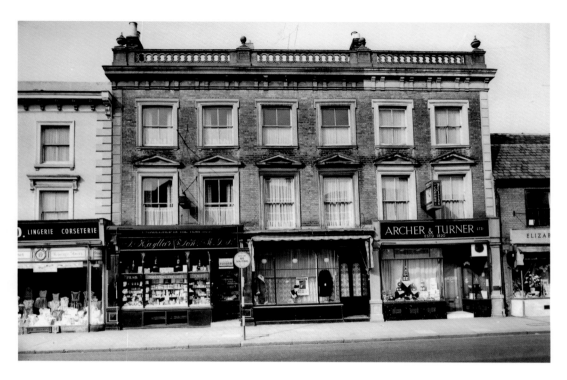

Shops, High Street, West Side

The shop on the left of the three storey block in 1962 was a chemist's, Hayllar's. He was also a local historian, who wrote *The Chronicles of Hoddesdon* in 1948. In 1962, the type of business of these shops was very different from today.

Lowewood Museum Borough of Broxbourne: Photograph 1982.91

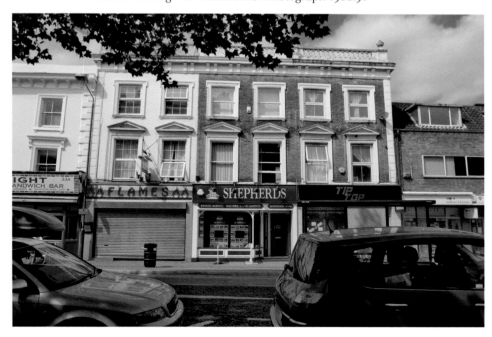

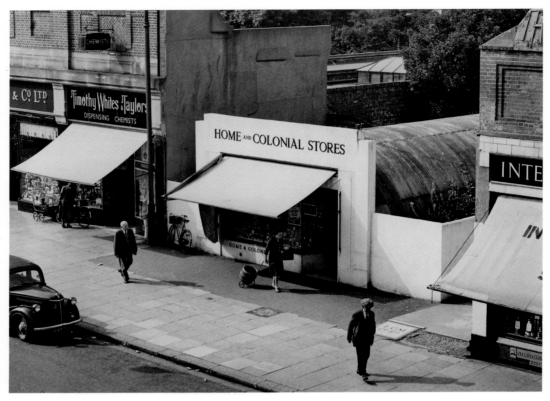

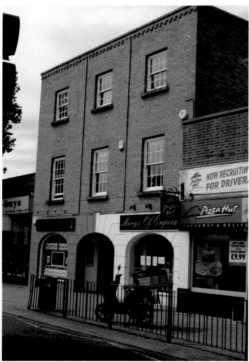

Shop with a Difference
At the slightly elevated angle of the 1950s view it can be seen that behind the façade was a Nissen hut. Nissen huts were manufactured near Rye House, and this one was erected following bomb damage in the Second World War. Far from the temporary structure intended, it lasted until near the end of the twentieth century.

Lowewood Museum Borough of Broxbourne: Photograph 1995.978

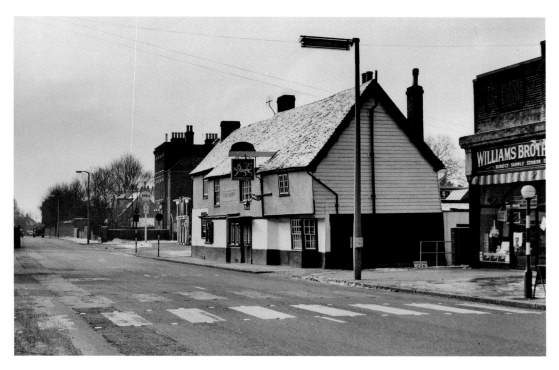

Golden Lion

Reputed to be Hoddesdon's oldest inn, the Golden Lion looks little changed, apart from extensions to the rear. Sherbourne House to its left was demolished in 1965, and the garage was expanded.

Lowewood Museum Borough of Broxbourne: Photograph 1982.142

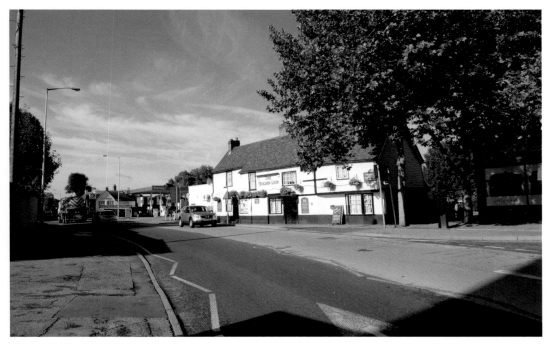

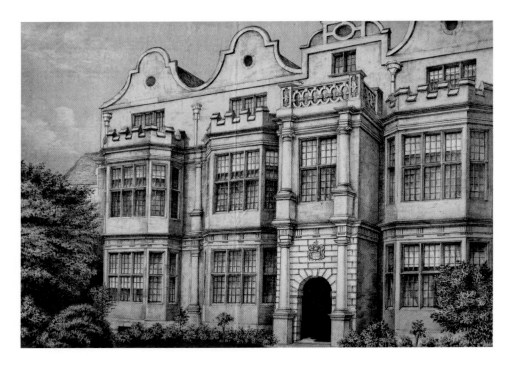

Rawdon House

Built by Marmaduke and Elizabeth Rawdon in the seventeenth century, the house had a piped water supply, a branch of which ran to the town centre to pour water from the Samaritan Woman's urn. Rawdon House was later a school, before becoming a private house in 1875, extended with the addition of the north wing. From 1898 to 1969 Rawdon House became the convent of St. Monica. Saved from threatened demolition it is now offices.

Lowewood Museum Borough of Broxbourne: Photograph 1982.82.44

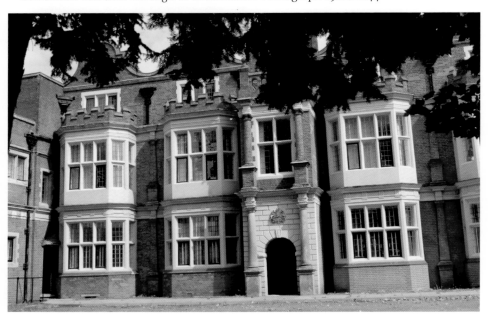

The Grange

The Grange was built by Rawdon's son, another Marmaduke, in the mid seventeenth century on the site of an inn, the Cock. It was extended by Arabella Oxendon who added the south wing in the eighteenth century. A school and then a private house until the late 1960s, it had grounds behind which have now been developed for housing. The gates, however, are still in existence, with Arabella Oxendon's monogram above them.

Lowewood Museum Borough of Broxbourne: Photograph 1985.424

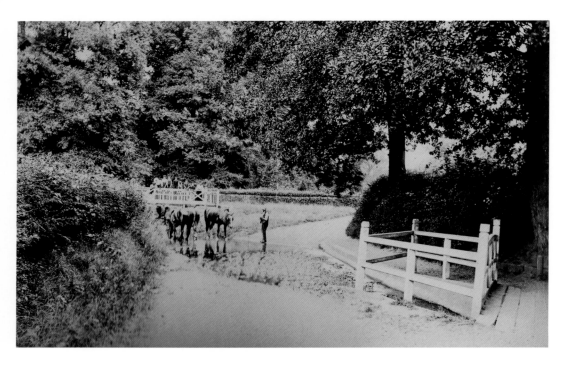

Cock Lane Ford

Cock Lane was sometimes called Grange Lane in the past, with allusion to Rawdon's house, but the older inn gives the lane its modern name. Although bypassed for modern traffic, there is still a ford where Spital Brook crosses the lane.

Lowewood Museum Borough of Broxbourne: Photograph 1982.84.6

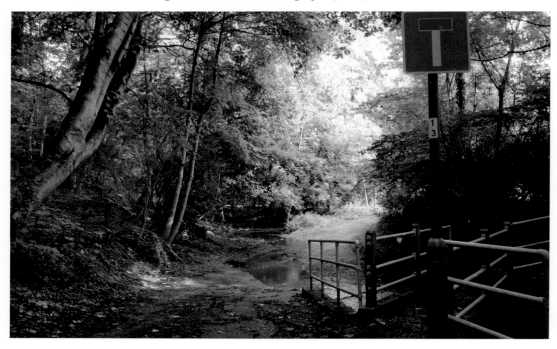

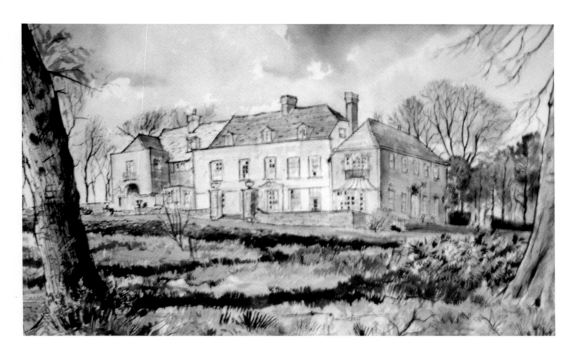

Sheredes

Sheredes House off Cock Lane, although Georgian in style, was built in 1929. The house had a short life, being demolished in 1963, but its name lives on. The site was used for housing and for Sheredes Primary and Senior Schools.

Lowewood Museum Borough of Broxbourne: Photograph 2002.0048

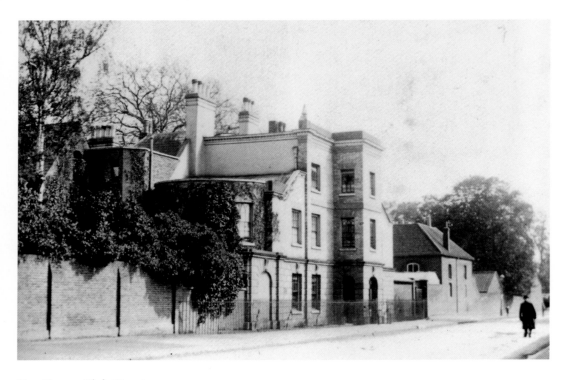

Yew House, High Street

Yew House probably dated from the seventeenth century, but was much altered in the early nineteenth century. Its occupants included Admiral Donat Henchy O'Brien for whom Admiral's Walk is named. Yew House was demolished in the 1960s and Cedar Green was built on its site. The stable block was converted to North and South Houses.

Lowewood Museum Borough of Broxbourne: Photograph 1982.219

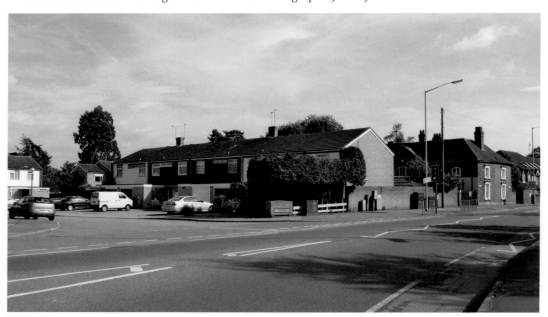

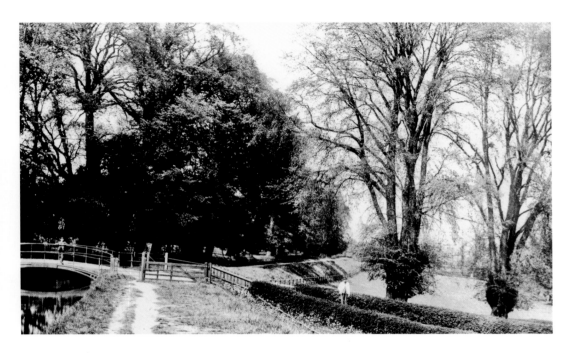

New River

Neither new nor a river, it was built in the early seventeenth century to supply drinking water for London. The bridge seen here in 1889 leads from Upper Marsh Lane to Admiral's Walk, which commemorates the walk the admiral habitually took down to the marshes. These marshes, now drained, are the site of the roads Admiral's Walk and the Meadway. There is now a modern footbridge in addition to the road bridge, because of increased traffic.

Lowewood Museum Borough of Broxbourne: Photograph 1994.213

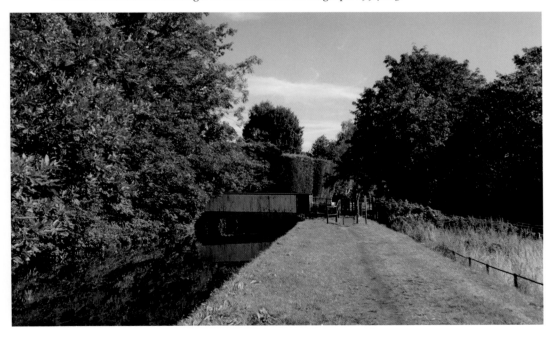

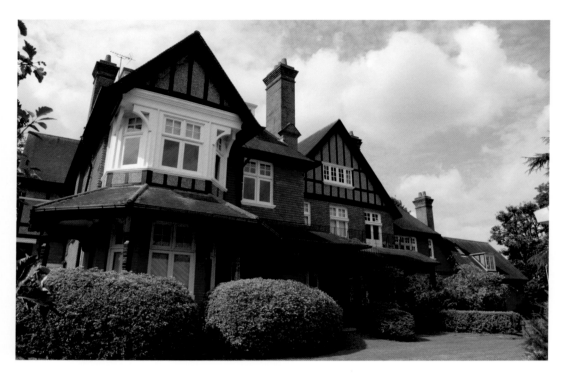

St. Cross

Church Path is an old path leading to the church of St. Augustines, Broxbourne. St. Cross, sited between Upper Marsh Lane and Church Path, became a Roman Catholic School in 1933. The house itself is now used as offices, with the school in more modern buildings.

Lowewood Museum Borough of Broxbourne: Photograph 2003.0023

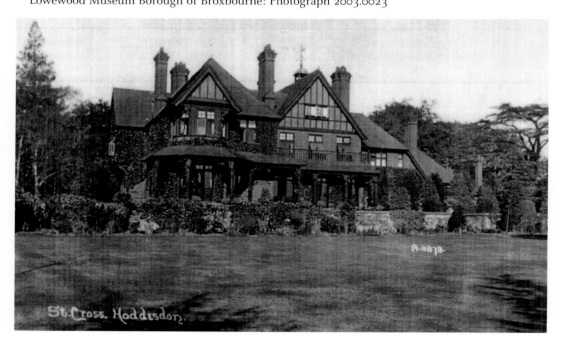

St. Cross. Hoddesdon.

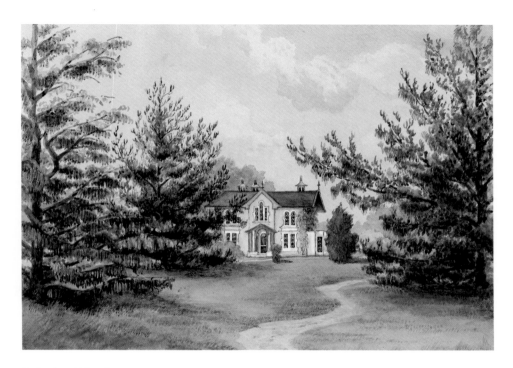

Spinning Wheel

Sited between the High Street and Church Path, The Italian Cottage was built by Septimus Warner in the mid nineteenth century. Later called The Cottage and by 1934 The Spinning Wheel, when it was described as a roadhouse. The open air pool opened in the 1930s, but now sadly is closed. The building itself is used as offices.

Lowewood Museum Borough of Broxbourne: Photograph 1982.82.186

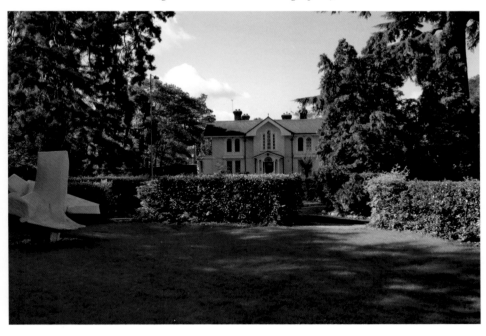

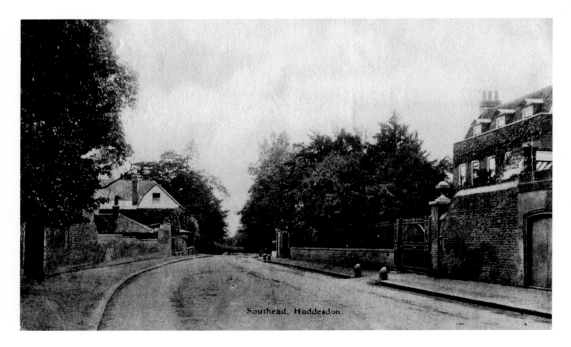

Southend, Hoddesdon.

Harteshorne and Lowewood

Looking south down the High Street, the earlier photograph shows Harteshorne on the left and Lowewood, masked by the brick wall, on the right. Owned by the Warner family in the nineteenth and early twentieth centuries, Lowewood was given to the town in 1936 as museum and library. The library now has moved to a central position in the town. Harteshorne, out of shot in the modern view, stands nearly opposite the Police Station.

Lowewood Museum Borough of Broxbourne: Photograph 1982.82.48

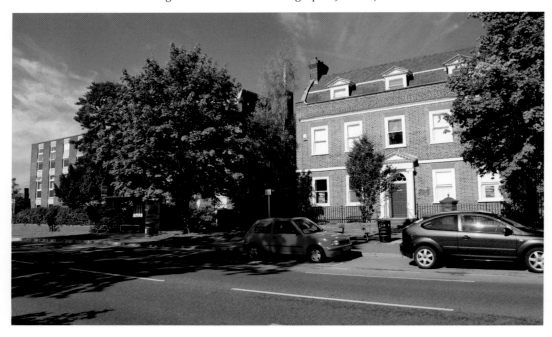

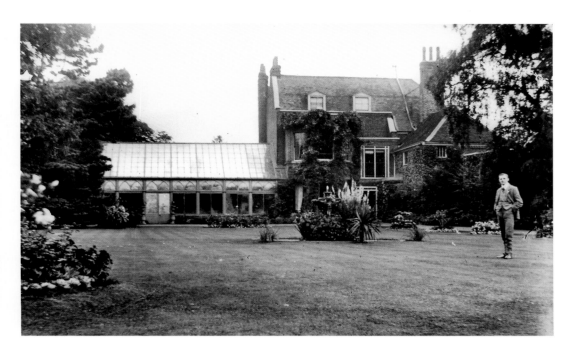

Lowewood, Rear

In 1900 a large conservatory abutted Lowewood. The main part of the house is Georgian, but the section at the rear right is older without the lofty ceiling height of the eighteenth century part. The Samaritan Woman statue stands to the left of the house.

 Lowewood Museum Borough of Broxbourne: Photograph 1977.294

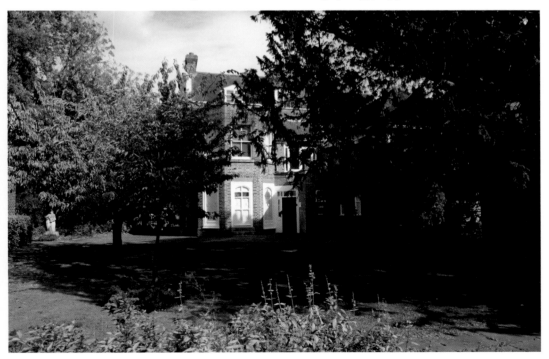

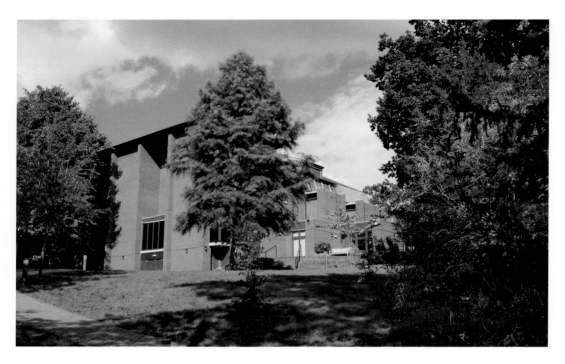

Agriculture to Entertainment
The Civic Hall, opened in 1976, stands to the west of Lowewood. It is a multi-function venue with pleasant grounds and a lake to the rear, from where the photgraph was taken. In the 1920s the view west from Lowewood was a completely rural one.

Lowewood Museum Borough of Broxbourne: Photograph 2001.0015

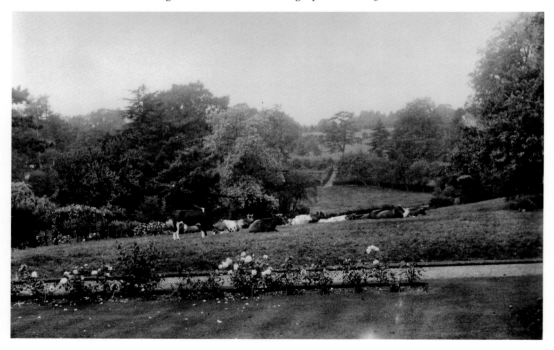

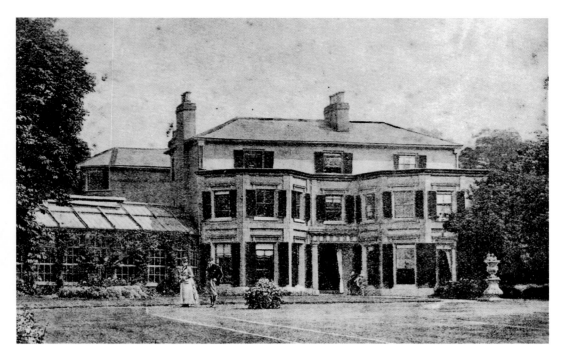

Woodlands

Woodlands was built in about 1830 by John Warner. The grounds of the estate lay west and south of the house, which was built abutting the High Street. Woodlands was demolished in 1967 and the Police Station stands on its site.

 Lowewood Museum Borough of Broxbourne: Photograph 2001.0002

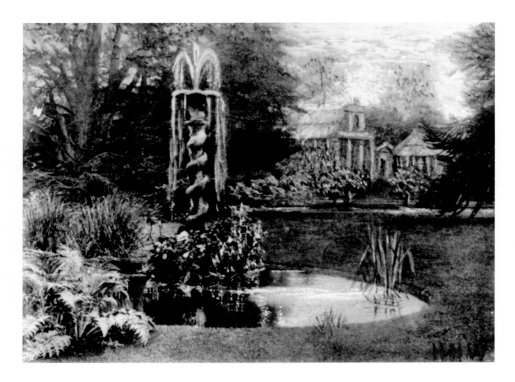

The Orangery

John Warner was interested in all types of gardening, laying out the Woodlands grounds with formal beds, walks, shrubberies, pools and features in artificial stone by Pulhams, such as this fountain. For more exotic plants there were conservatories and the orangery, which has been converted to a private house.

Lowewood Museum Borough of Broxbourne: Photograph 2001.0003

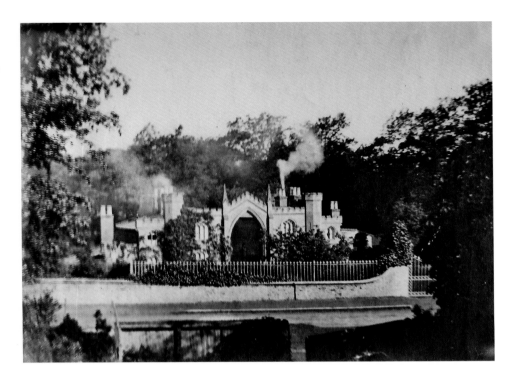

Gothic Cottages

Built at Spitalbrook at the southern end of the Woodlands estate one of these fanciful little cottages was home to John Warner's gardener, James Williams, who worked for the Warner family for seventy-four years. He died in 1892 aged ninety-five, a few years before this photograph was taken. The Avenue now stands on the site of the cottages.

Lowewood Museum Borough of Broxbourne: Photograph 1982.82.106

Broxbourne

Early forms of the name Broxbourne were Brochesbourne and Brokesbourne. Although the badger was and still is found in the district the notion that the name translated to "badger's stream" is probably fanciful. It is however much more likely that its origins were in the Anglo-Saxon personal name Brocc. The stream or brook in question was possibly Spitalbrook, which still forms part of the northern boundary between Broxbourne and Hoddesdon.

Prior to the Norman Conquest the manor of Broxbourne was held by Stigand the Archbishop of Canterbury. In 1070 he was deprived of his post and estates by William I and by the time of the Domesday survey of 1086 the manor lands were in the hands of Adeliza, wife of Hugh de Grantemesnil, who was one of William's Barons. At this time it was taxed as five and a half hides – approximately 800 acres – and was valued at four pounds.

The histories of Broxbourne and Hoddesdon have always been closely linked and although Hoddesdon developed its own identity from the thirteenth century, a large part of the town remained within the parish of Broxbourne until 1844. Much of the western boundary of Broxbourne is formed by the remains of the Roman road Ermine Street which ran from London to Lincoln.

This route was more or less abandoned when the "Old North Road" was opened through the lower part of the Lea Valley. It was on this road that the village of Broxbourne became established with its centre at the junction of the High Road and Mill Lane. Mill Lane was an important road, because it not only provided access to the mill, mentioned in Domesday Book, but also to Nazeing and Essex via the Broxbourne toll bridge over the River Lea and the road now known as Old Nazeing Road.

Following the dissolution of the monasteries under Henry VIII Broxbournebury Manor came to the crown, before being granted to John Cock in 1544. It is not certain whether Broxbournebury mansion was built by him, or his son Sir Henry Cock but it remained the seat of the Cock and Monson families until 1789. In this year the house and estate of 1100 acres were sold to Jacob Bosanquet, a Hugenot who was to become Chairman of the East India Company and in 1802, Sheriff of Hertfordshire. Bosanquet's estate consisted of large areas of land in

the village and much of this remained in the possession of the family until the estate was sold in 1946.

During the late eighteenth and early nineteenth centuries Broxbourne's principal inns, the King William and the Bull Hotel would have serviced some of the many coaches that passed through the village daily. However the majority of these coaches used the numerous inns and hostelries of Hoddesdon. The coaching trade went into decline when the Northern and Eastern Railway Company opened their railway from Stratford Junction in East London as far as Broxbourne on 15 September 1840. For a short period of time Broxbourne was the northern terminus for the line, but it was eventually extended as far as Bishops Stortford by May 1842.

George Jacob Bosanquet succeeded his father in 1830 and he saw the potential to develop his land close to the station and had a number of villas constructed on Court Field, now part of Churchfields in the 1850s. He shrewdly retained the freehold of these properties as well as large areas of land in the village and by this means he was able to control the pace of development. Other houses were built by him along Churchfields and also in Pound Lane which later became Station Road. The new villas were inhabited by merchants, military men, businessmen and professionals; as well as gentlemen fund holders and wealthy widows.

The next most significant development was the construction of the St. Catherine's Estate in the 1880s, but as this was on the northern edge of the village it did not impact greatly on day to day village life. On 17 March, 1910 twenty nine acres of Broxbournebury estate land was offered for sale by Hoddesdon estate agents Bridgeman and Son. This sale eventually led to the development of the west side of Churchfields, St. Michael's Road, New Road and Springfields. The First World War and the poor state of the economy post war delayed the construction of houses until the late 1920s and early 1930s, but when building started so began the suburbanisation and the development of the Broxbourne of today.

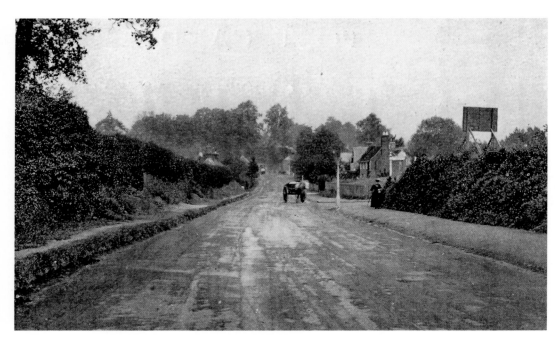

Spitalbrook

The view looking north towards Hoddesdon about 1910. The hoarding on the corner of New Road is advertising building land for sale. Just beyond New Road is Spitalbrook farmhouse, which was owned at the time by the Frogley family.

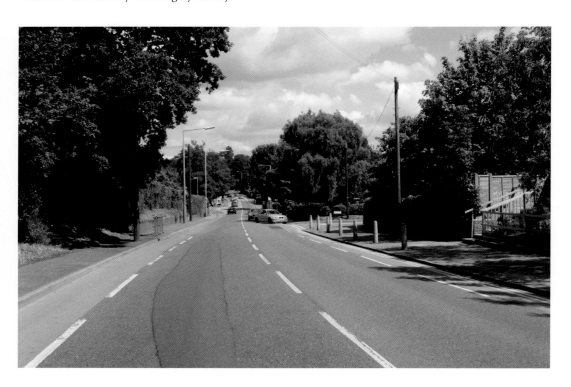

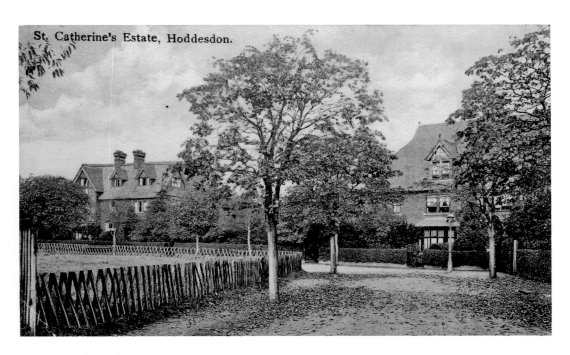

St. Catherine's Estate, Hoddesdon.

St Catherine's Estate

This attractive estate was built in the 1880s by John Alfred Hunt and his partner, Thomas Hunt. They leased land from the New River Company and built a number of fine architect designed houses. A number of the original houses survive, although there has been some infilling of vacant plots.

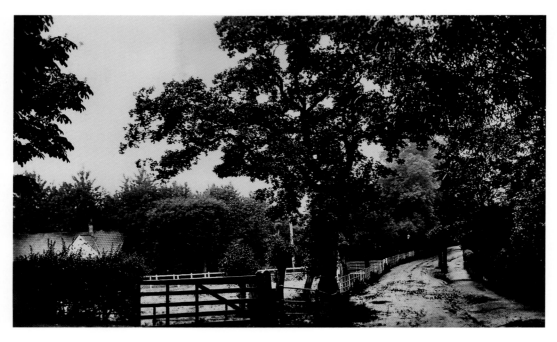

Osborne Road

This very rural looking road was also part of the St Catherine's Estate. Hunt's only developed the right hand side of the road as shown on this view dating from about 1905. The land behind the field gate was divided into plots but was not built on.

New Road/High Road

Spitalbrook Farmhouse was once home to Van Hage's. The company took the 20 foot high windmill with them when they moved to their new premises at Great Amwell. The Westcroft Court development was built on the vacant High Road site.

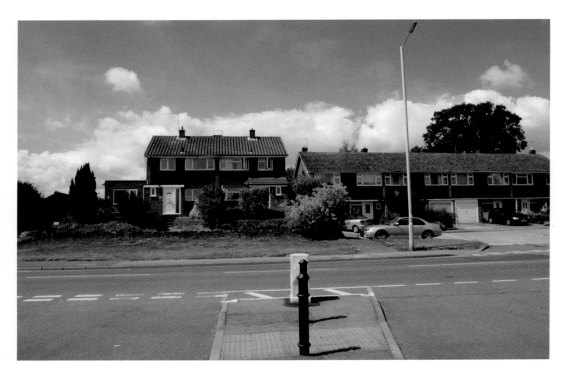

La Fosse, High Road
Situated directly opposite St. Michael's Road it is difficult to imagine that this plot, now completely built upon was once a sanctuary for two donkeys. The owner obviously took great pride in his well manicured hedges.

Lowewood Museum Borough of Broxbourne: Photograph 1982.317

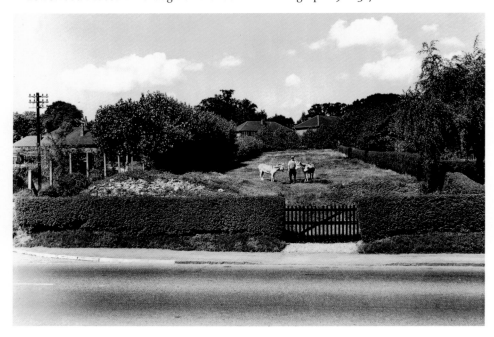

St John's Parade

Broxbourne's busy parade of shops takes its name from an estate agent and auctioneer, Mr. F. R. St. John. The parade was constructed in the early 1930s to serve the growing number of houses being built on land that had once belonged to the Broxbournebury Estate.

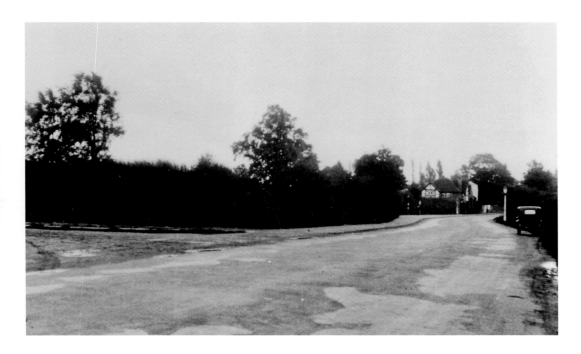

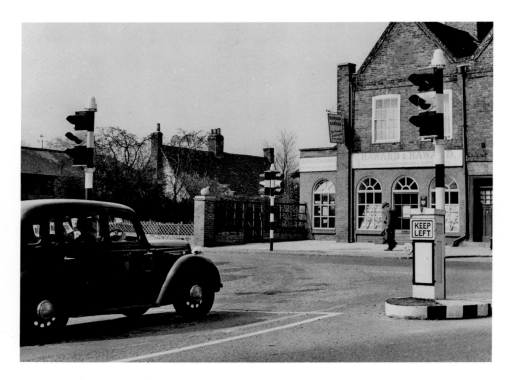

High Road/Station Road

The traffic lights at Station Road came into operation on Monday 24 March 1952. This photograph appeared in the April edition of the *Hoddesdon Journal*. Fifty years on the junction remains one of the busiest in the area.

Lowewood Museum Borough of Broxbourne: Photograph 1985.582

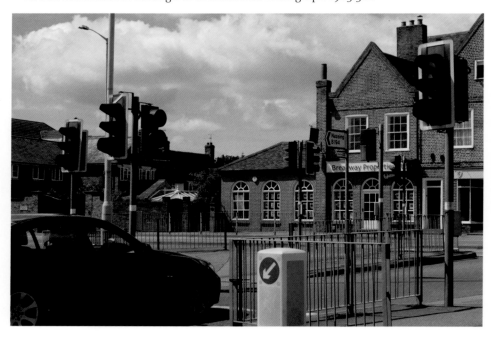

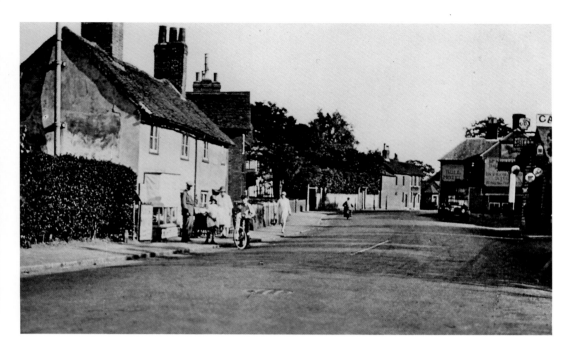

High Road/Bull Hotel

This 1920s view of the original village centre portrays its rural nature. The motor car is parked outside the Bull Hotel which is mentioned in documents as early as 1521 and was probably at its busiest in the early nineteenth century when it was a coaching inn. It was demolished and replaced by a modern pub in 1972.

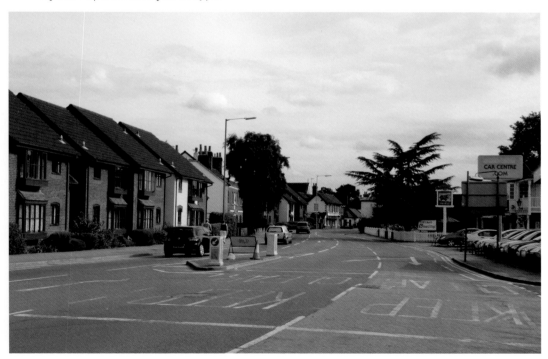

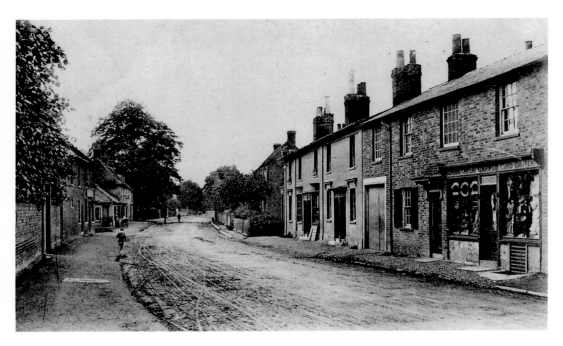

High Road looking South

Broxbourne had very few shops in the early years of the twentieth century and nearly all of them were situated in properties along the High Road near the junction with Mill Lane. Those that survive, including Mr. Garrod's general grocery and drapery store, have been converted back to private dwellings.

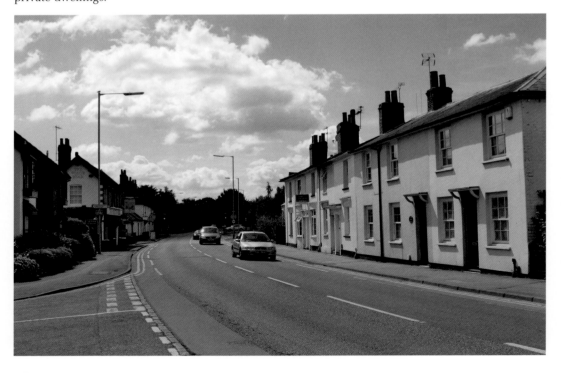

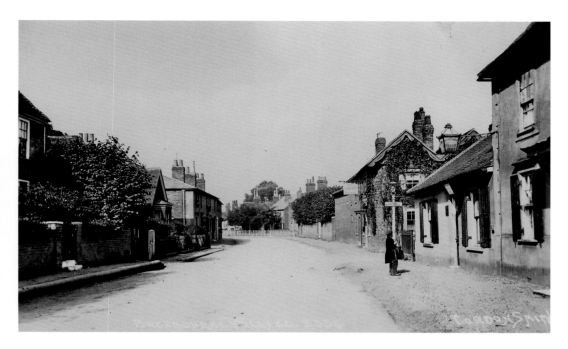

Broxbourne Post Office

For many years the single storey building at the top of Mill Lane was the village Post Office. The sign on the lamp post in front of the White Bear points the way to Broxbourne bridge. Broxbourne no longer has a Post Office. The White Bear dates from the eighteenth century.

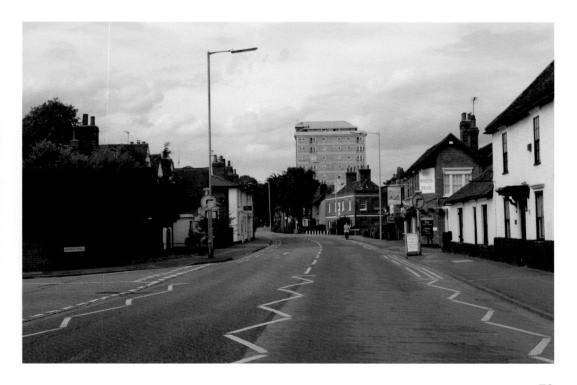

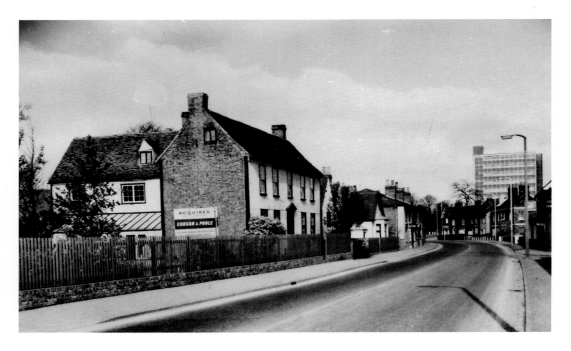

Manor Farm

In 1968 the estate agents board announces the fate of Manor Farm. Part of the farmhouse dated from the seventeenth century but it had been altered in the eighteenth century as was the fashion. However this did not prevent it from being demolished to make way for the Monson Road Estate.

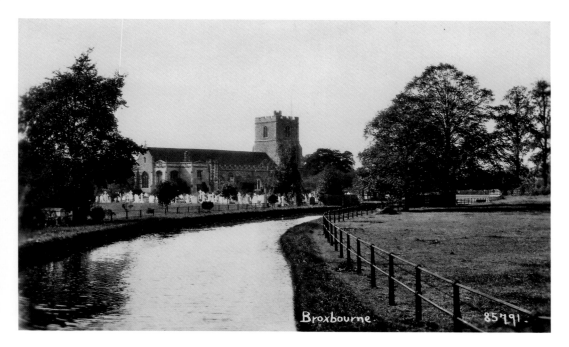

St Augustine's Church/New River

Construction of the main part of the church, which was completed in about 1460, was financed by Sir John Say. The Say Chapel, the south aisle and the tower were added by Sir William Say who was knighted by Richard III in 1483. It is one of only five Grade I listed buildings in the Borough of Broxbourne.

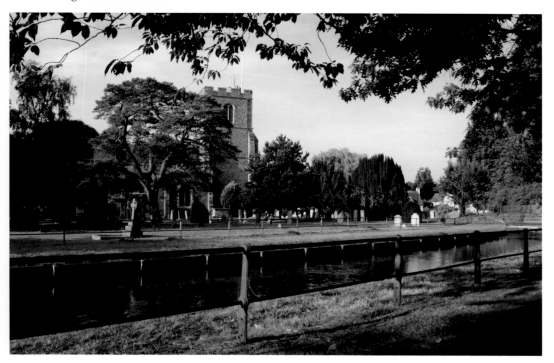

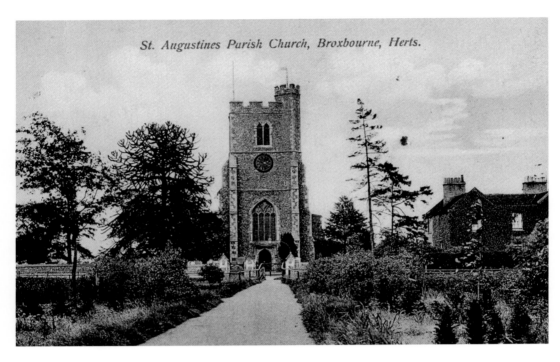

St. Augustines Parish Church, Broxbourne, Herts.

St. Augustine's Tower/Vicarage
The church was a popular subject with Edwardian postcard publishers and numerous views like this one were produced in the early 1900s. The view is little changed today.

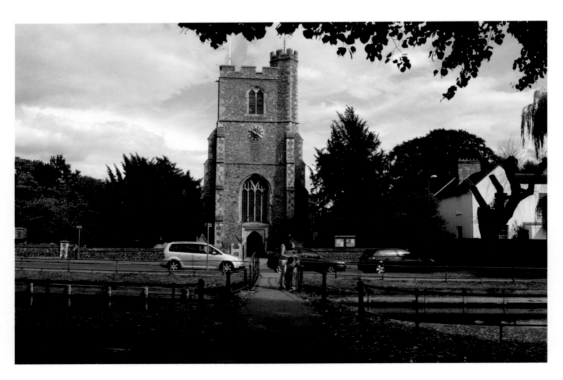

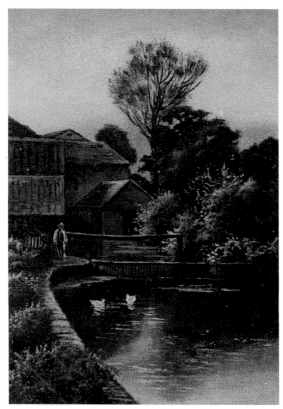

Old Mill
This artist's impression of the mill dates from about 1900. The mill and the adjoining miller's cottage were destroyed by fire on 1 October 1949. The site has been cleared and landscaped by The Lee Valley Regional Park Authority and is now a popular area for visitors.

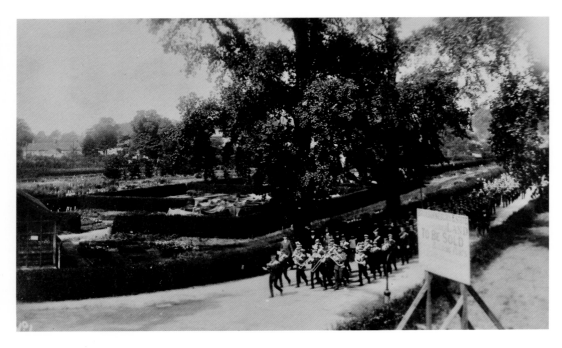

Recreation Ground

The Herts Yeomanry marching down Station Road towards Broxbourne Church in 1912. The nursery gardens in the background were owned by G. Paul and Sons. Today this area is the Broxbourne Recreation Ground.

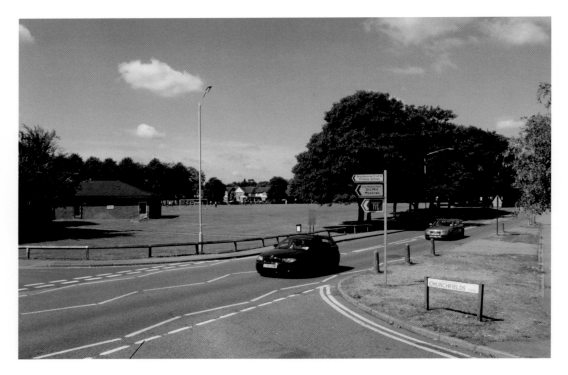

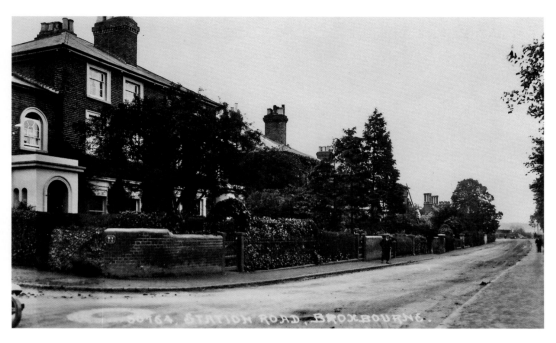

Station Road

Station Road was originally known as Pound Lane and prior to the arrival of the railway in 1840 it only provided access to the water meadows on the west bank of the Lea Navigation. The impressive villas were built in the early 1850s by George Jacob Bosanquet of Broxbournebury.

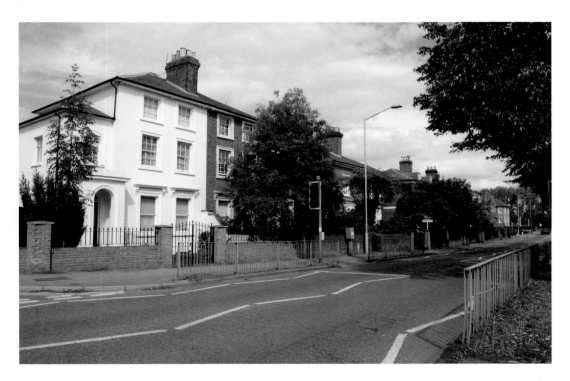

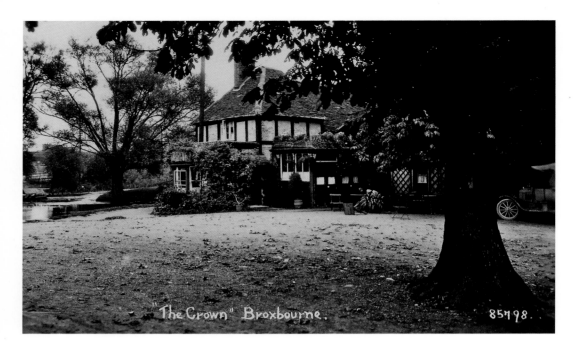

"The Crown" Broxbourne. 85798.

The Crown

The 1876 handbook Environs of London recommended a visit to the Crown at Broxbourne and its "unequalled gardens". These offered the visitor a variety of walks and vistas and the opportunity to participate in archery, croquet and bowls. The present Crown, although refurbished in recent years, was built in the 1930s.

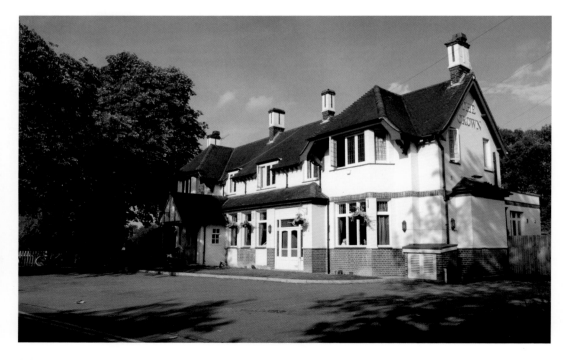

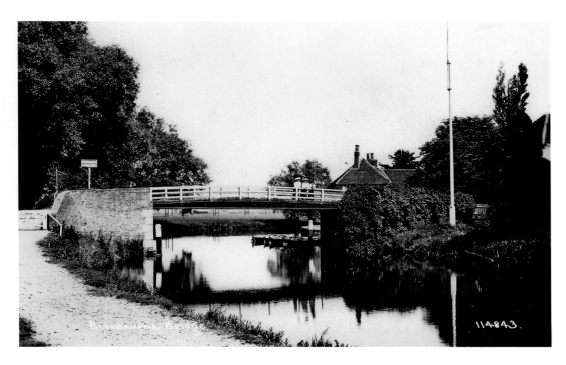

Broxbourne Bridge

Originally a toll bridge which carried the road from Mill Lane over the Lea Navigation. The county boundary between Hertfordshire and Essex runs down the middle of the navigation effectively dividing the bridge in two.

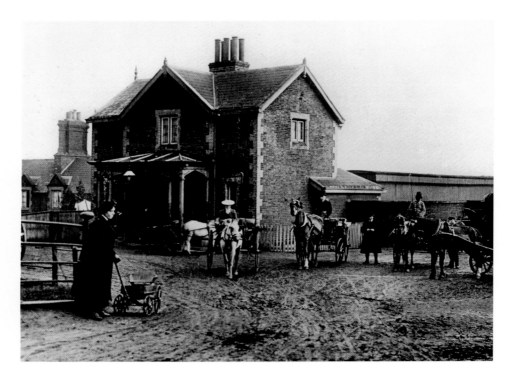

Broxbourne Station

This posed photograph taken at the entrance from Station Road about 1905 shows to good effect the well proportioned station house with its timber portico. By contrast, the view from fifty years later shows the station house without its portico, but now with an ugly single storey building attached to it.

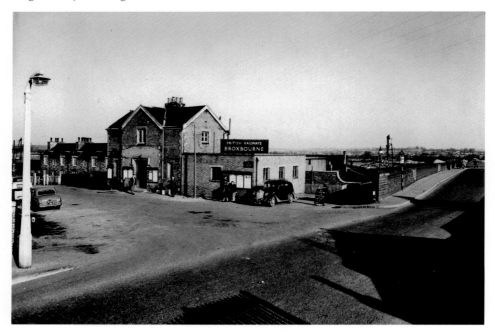

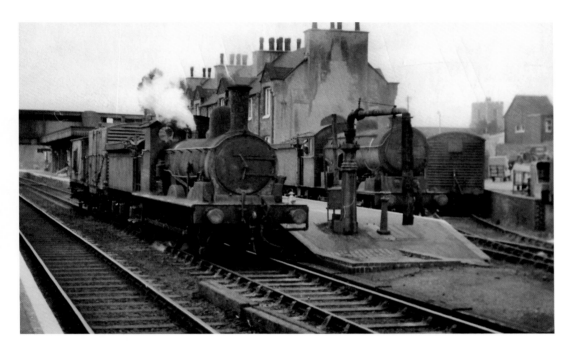

Station interior

Steam was still the main motive power for passenger and goods traffic up until the late 1950s, when work began on the new Broxbourne Station. Officially opened on 3 November 1960, the present station was listed Grade II on 2 March 2009.

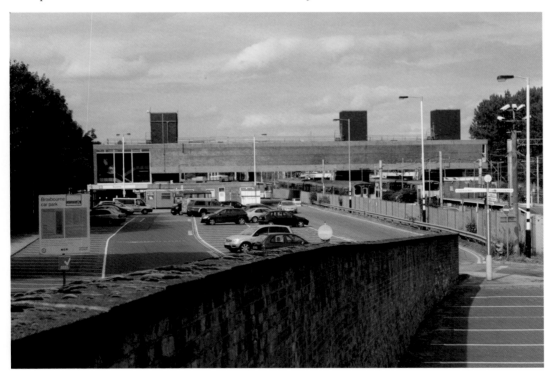

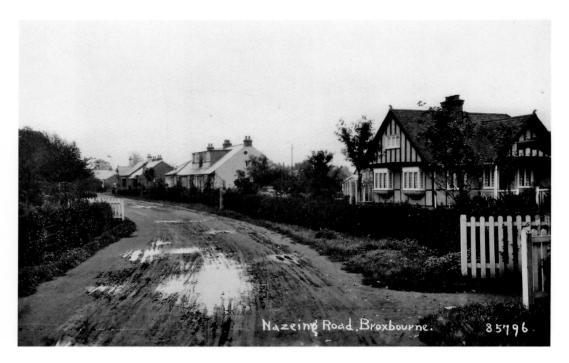

Old Nazeing Road
This was the original route from Broxbourne to Nazeing before the new road bridge over the railway opened in January 1909. Development began when land around Keysers Farm was sold, but progress was halted by the First World War.

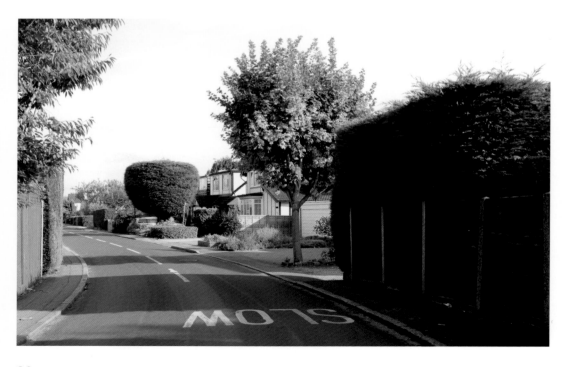

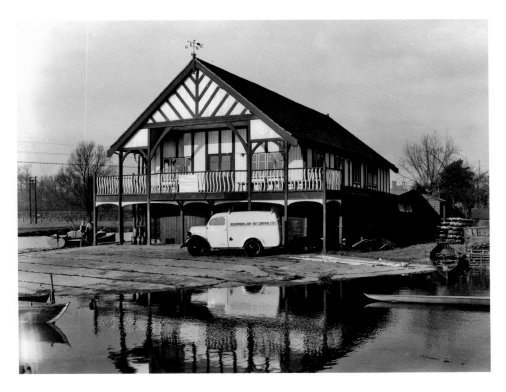

Boat House

The origins of Broxbourne Rowing club go back to 1847. This is a view of the clubhouse and boathouse, which was destroyed by fire in 1965, a fate which also befell its predecessor in 1905. Despite these and other setbacks the club is still thriving and competing in regattas.

Lowewood Museum Borough of Broxbourne: Photograph 1983.620

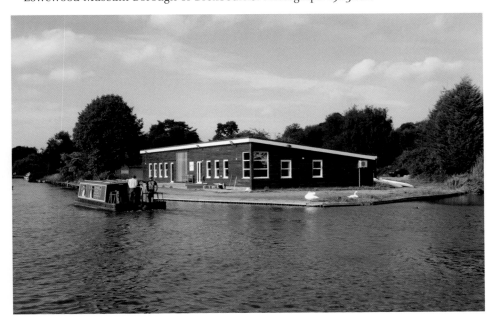

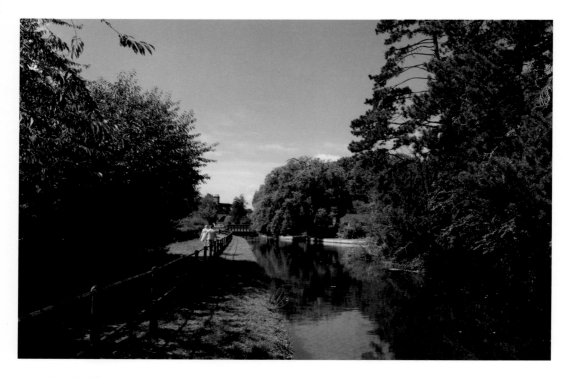

New River/Bridge House

The New River was constructed from 1608-1613, to carry fresh water into the heart of London. It meanders its way through Broxbourne and passes under the High Road by Bridge House. Remarkably, the view of the river from this point has hardly changed in 100 years.

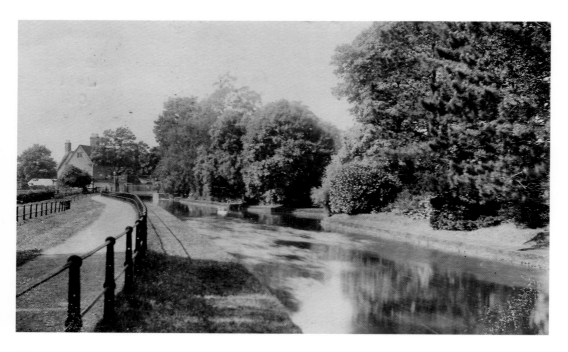

The Gables

This house featured in *An Inventory of Historical Monuments of Hertfordshire*, published in 1910. It dated from about 1600 and had exposed beams and open fireplaces. The brick chimney shaft through the centre of the building was completely independent of the timber framework of the building and would have been a later addition. Together with the seventeenth century cottages just beyond it, The Gables was demolished in 1964.

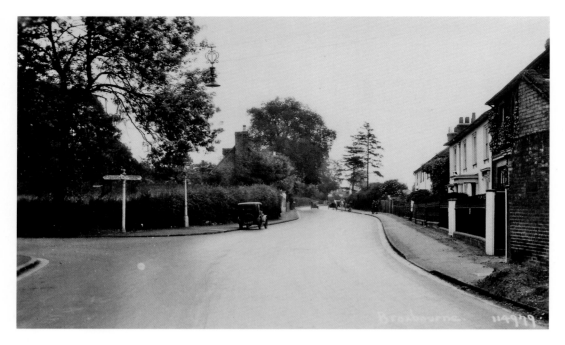

Bell Lane/High Road

Behind the hedge on the left hand side of the road was an open site once occupied by the King William Inn which was badly damaged by a fire sometime after 1871. On the right are two large houses, Thornbury and Roundfield House. The narrow entrance into Bell Lane is in marked contrast to the roundabout and widened road of today.

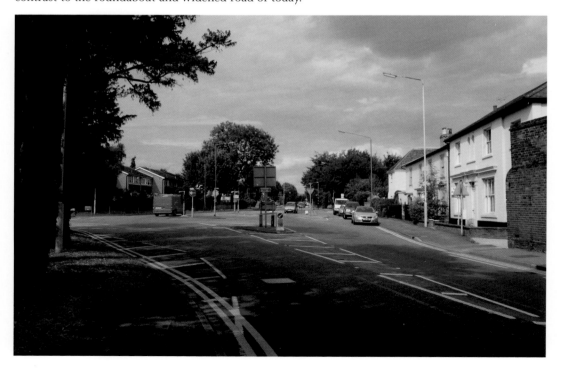

Baas Hill Common

The common has always been a popular venue for outings and picnics especially during the Edwardian era. In the 1970s the area of the common was drastically reduced by the construction of the A10 bypass. Today the road is considerably busier although what remains of the common is still a popular area, particularly on summer weekends.

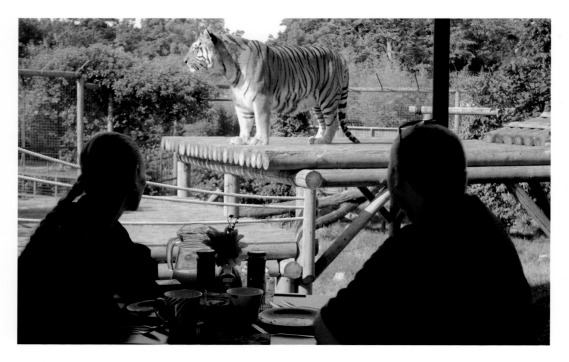

Broxbourne Zoo
The Sampson family saw through the very poor reputation of Broxbourne Zoo when they purchased the site in 1984. They renamed it Paradise Wildlife Park and Woodland Zoo and after many years of hard work, the attraction now has a very good reputation and attracts in excess of 300,000 visitors per year.

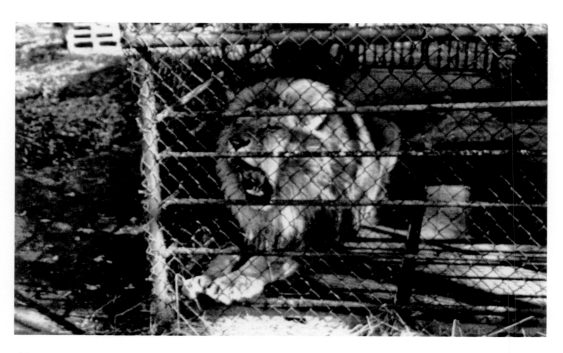